LOWRY'S CITY

A Painter and his Locale Judith Sandling and Mike Leber

LOWRY PRESS

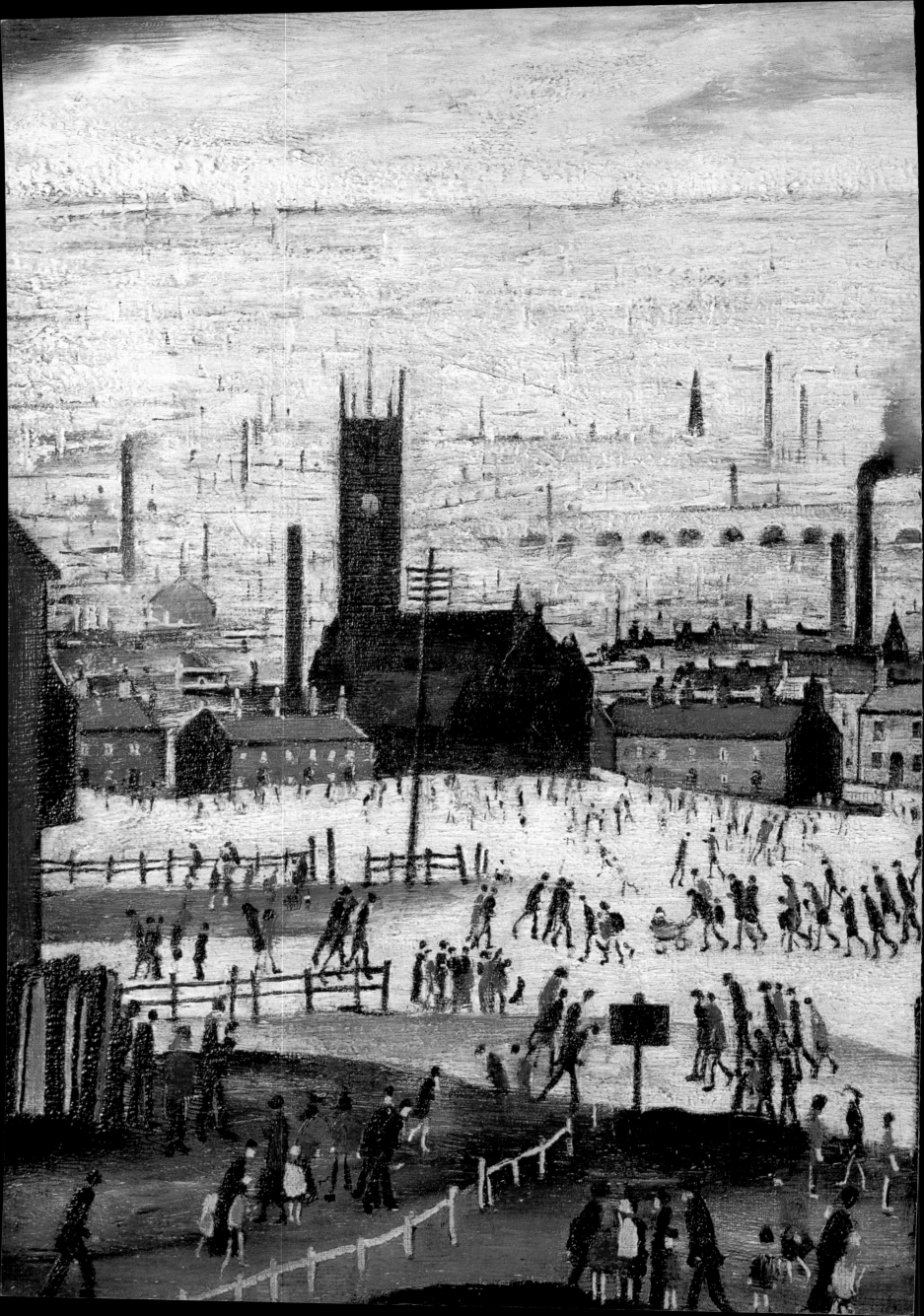

LOWRY'S CITY

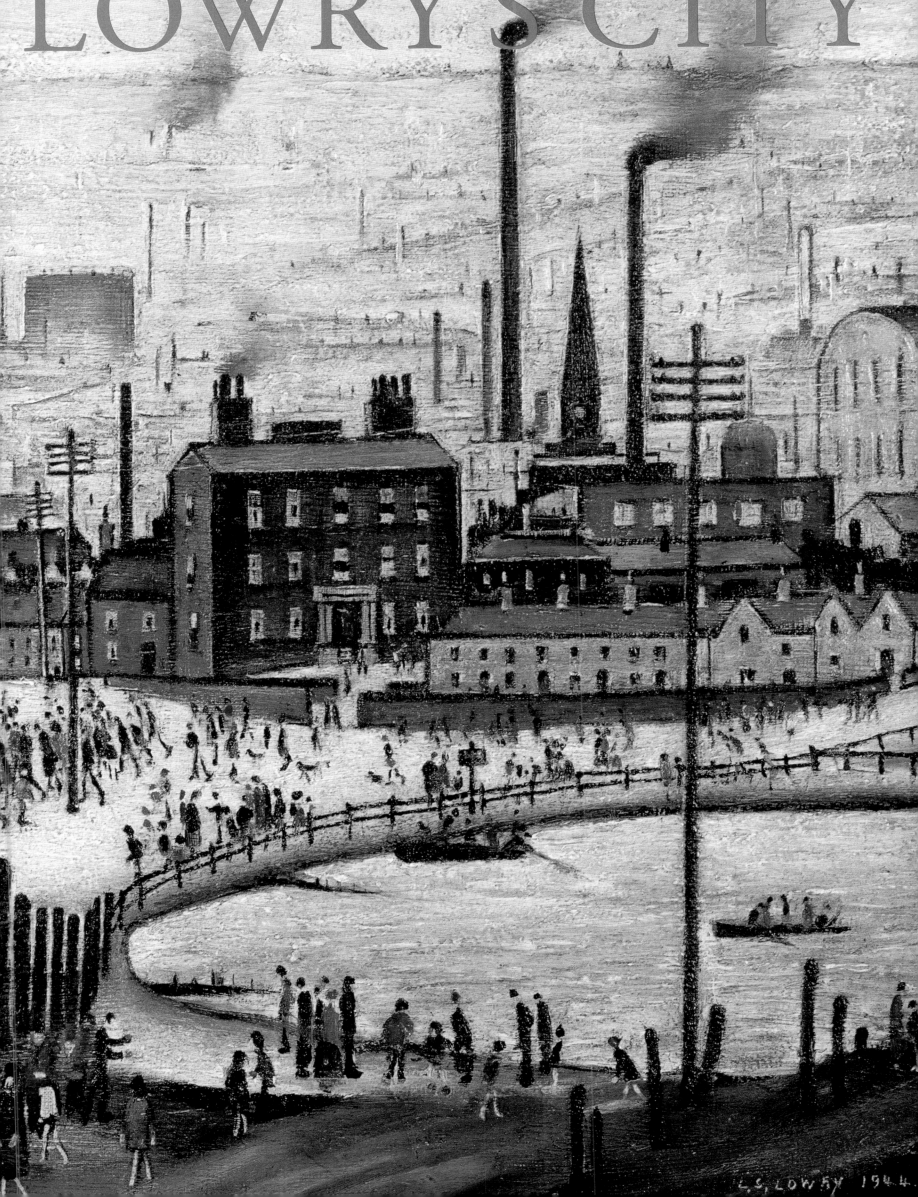

L.S. LOWRY 1944

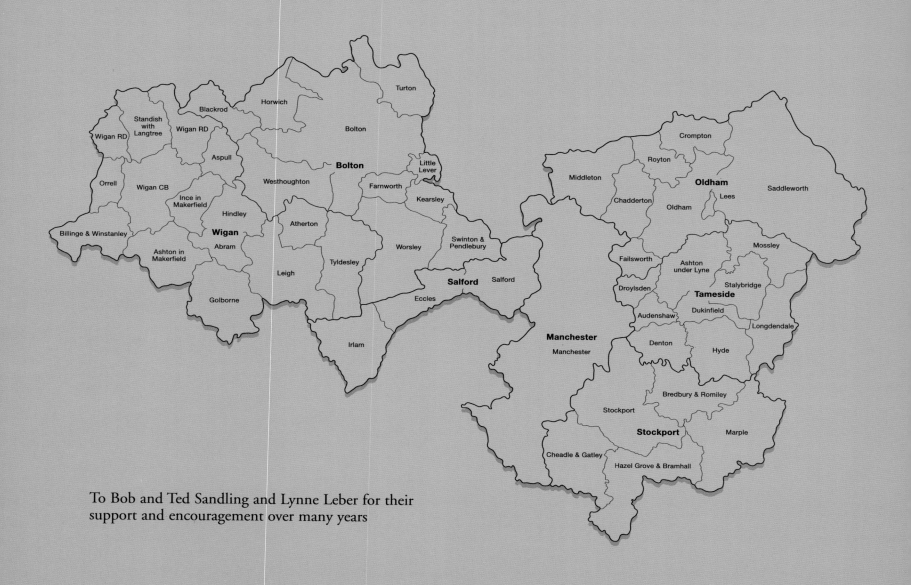

To Bob and Ted Sandling and Lynne Leber for their
support and encouragement over many years

Title page *An Industrial Town* (1944),
oil on canvas, 45.8 x 60.9 cm.

The Lowry
Pier 8 Salford Quays Salford M5 2AZ
Telephone 44 (0) 161 876 2020
Fax 44 (0) 161 876 2021
www.thelowry.com

Publishing and editorial direction by Roger Sears
Art direction by David Pocknell
Edited by Michael Leitch
Designed by Martin Tilley and Becky Taee at Pocknell Studio
Production management Luci Heyn

First published 2000
© The Lowry Centre Limited and the authors
A CIP catalogue record for this book is available from The British Library
ISBN 1 902970 05 5
Originated in Hong Kong and printed and bound in Spain by Imago

Contents

Introduction: A Painter and his Locale

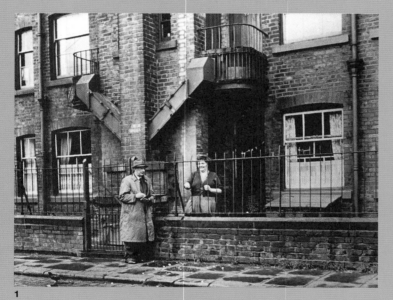

1

A tall man with angular features and piercing eyes makes his way down a street of terraced houses. He is set apart, not merely by his three-piece suit, raincoat and trilby hat but also by his awkward, rather gangly walk - the right and left feet competing to proceed in entirely different directions - and a tangible sense of purpose.

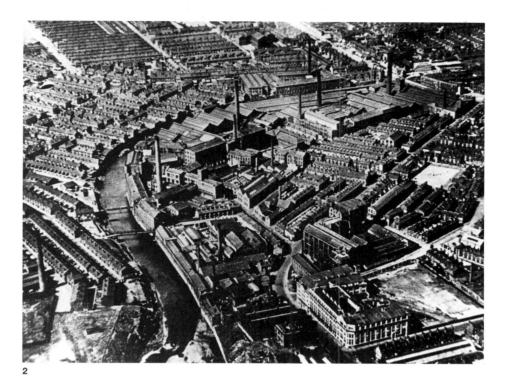

2

He is no stranger to such streets, but he is probably unknown to the residents. He scrutinises all before him, not just the layout and architecture, but also the mundane and unusual incidents of everyday street life. Women may be sat chatting on front-door steps and children are probably playing in the street. They ignore the man who appears not to notice them.

Suddenly the man stops. He fumbles for a well-worn pencil and selects an old postcard, envelope or scrap of paper from his jacket pocket. Leaning at a curious and precarious angle against somebody's house, he starts to draw - a window, a house, a church, the street. The children are now curious but their questions and antics go largely unacknowledged. Except that when, a few minutes later the sketch is completed, the man may 'accidentally' drop a few coins for the children to discover.

Another of L S Lowry's places has been added to the vast and ever-growing catalogue of images which the artist could use in the 'dreamscapes' he composed at home. In due course, these urban landscape paintings, made largely of composite images from many places, assumed a peculiar reality and were seen as representing the industrial North-West of England. Lowry's obsessive vision, portrayed in his unique style and palette of just five colours, came to embody both the time and the place.

That Lowry's art should epitomise a time - that period between the two great wars of the 20th century - is of course coincidental. Lowry was responding to his contemporary scene. He was neither recalling a past golden age nor anticipating the future. He recorded and interpreted, with

pencil and paint, what he saw and how he saw it. He was, though, quite unconsciously and equally coincidentally portraying the terminal decline of the Industrial Revolution. The places which feature in his urban landscapes and the people who inhabit them were about to change forever.

Lowry was aware of the change, but nobody could foretell how swift and radical this economic, social and environmental upheaval would be. Thus, most of the terraced streets and cotton mills immortalised in his painting were swept away in an orgy of demolition. The compact, disorganised, primitive and overcrowded rows of houses were replaced in the 1950s and 1960s by tower blocks, the so called 'streets in the sky' which in turn are now being cleared to make way for town houses and new terraced streets!

If Lowry's depiction of a particular period of time was coincidental, then his sense of place might almost be attributed to fate. Born in 1887 to middle-class parents and raised in the very select and comfortable suburbs of South Manchester, there was nothing in Lawrence Stephen Lowry's early life to suppose that he might become a painter of industrial scenes. Indeed, his early drawings and paintings of places focus not on cotton mills but on yachts and are very much of the Victorian tradition. Even though he was walking the streets of Ancoats and other districts of Manchester collecting property rents from around 1905, those streets had no apparent appeal. They were, after all, a world away from the greenery and civility of his refined home in Victoria Park.

Sadly, the Lowry family's middle-class life was not matched by sufficient income to maintain the style to which they aspired. So, in 1909, the family

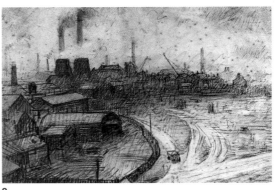

moved to rented accommodation at 117 Station Road, Pendlebury, close to the main road between Manchester and Bolton. The implied social disgrace was clear, but without this apparent catastrophe it is unlikely that Lowry would have taken any interest whatsoever in industrial society.

He had found, unwittingly, the place which, along with nearby Salford where he studied drawing at the School of Art, and Manchester where he collected rents, would provide him with endless stimulation and countless images. The familiar, if somewhat impoverished, middle-class lifestyle continued, but the mind of the young artist was to become dominated by the life, work and play of the working class. He was, however, always to remain detached, aloof and remote, never wishing either to join the workers' daily struggle or to make political statements through his art. Such was the power of these places that, when they began to change, he narrowed his vision from the industrial town as a whole to the people in it, depicting first of all relatively large concentrations, then small groups and eventually individual figures.

Again, much as a result of coincidence and pressure, Lowry moved in 1948 from Pendlebury. He took up residence in Mottram-in-Longdendale on the edge of the moors and found new places in the North-East of England and South Wales. But it was North-West England that dominated his life for nearly forty years.

Touring Pendlebury, Salford and Manchester today, it is extremely difficult to visualise these districts as they were in the early part of the 20th century. Even where the modern visitor can catch a passing glimpse, it is a fragmentary experience. The whole picture has long gone, consigned to history. The

poorly built terraced streets of houses, lacking inside toilets and bathrooms, were crammed into every available space not occupied by huge, noisy cotton mills, metal foundries, engineering factories and dye works, pumping acrid fumes into the air and discharging lethal chemical cocktails into rivers which ran black and lifeless.

Houses and factories alike belched forth the smoke from a million coal fires, creating vicious smogs blackening every building, whilst also ruining the weekly wash and destroying the lungs of the residents. These working people endured a daily struggle to feed, clothe and provide for families which often embraced eight or more children. Mice, rats, cockroaches, rickets, tuberculosis and dyptheria were a routine part of life, which in general consisted of six days of hard labour each week.

The human spirit was refreshed each Sunday, in the numerous churches and chapels, whilst leisure consisted of a stroll in the park, a visit to a museum, a rare night out at the music hall or early cinema and the delights of the annual charabanc trip to the seaside. Ironically, within this hostile environment, community pride flourished. Extended families lived in close proximity; the front door step and even the pavement and kerb were scrubbed weekly and polished with a 'donkey stone' acquired from the rag-and-bone man. Sick and elderly neighbours were nursed and nurtured, and people of all ages rejoiced in the annual Whit Walks and other celebrations.

This world existed within a short walk of Lowry's Pendlebury home. Newton Mill, with its associated bowling green; Acme Mill, where the terraced

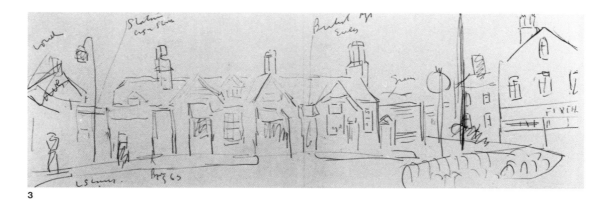

3

1 *Newtown Mill and Bowling Green* (1928), pencil on paper, 24.6 x 35.0 cm. Situated just a few hundred metres from Lowry's home in Pendlebury, this is one of the very few places depicted by the artist which survives.

2 *View from a Window of the Royal Technical College, Salford looking towards Broughton* (1925), pencil on paper, 26.5 x 36.5 cm. This picture was drawn from the building in which Lowry took part-time drawing classes from 1915 to 1928.

3 *Eccles Railway Station* (1963), blue ballpoint pen on paper, 12.8 x 35.6 cm. This is an annotated preliminary sketch for a subsequent drawing.

houses ran almost to the base of the mill and where the only open space was a bare-earthed 'croft' delineated by a boundary of wooden posts which the locals called Stump Park, and Newton Colliery, where men risked life and limb to win the precious coal - all were near-neighbours.

For many years, Lowry undertook part-time drawing classes at the Peel Building close to Salford's elegant Crescent. From the life classrooms and other top-floor spaces, Lowry could survey and record the panorama over Peel Park and the River Irwell, across the industrial areas of Broughton, Pendleton and Trinity towards Manchester. Nearby, houses of the Georgian period had survived and these held a particular attraction for the artist. Most of all though, there was the park, an oasis of green in a land besmirched with grime, where the masses would gather to escape the drudgery of everyday life.

In Manchester, Lowry had no need to make deliberate tours of exploration. His rent collecting took him throughout the poorer districts which surrounded the city centre. In particular, an area known locally as Irktown, where the poisonous River Irk wound its way to join the Irwell on the fringes of Ancoats, became a special place in his work. Other towns - Stockport, Ashton, Bolton and the like - contributed different images, including viaducts, unusual canal bridges, peculiar churches and haunting houses. There was no shortage of places for Lowry to select.

Surrounded by countless potential images, Lowry's precise choice of place tended to be governed by a set of criteria. Familiarity was vital; rarely did Lowry choose a subject on first acquaintance. The place or building had to be seen and

comprehended in every guise - in sunshine or in rain, throughout the various seasons and from different angles against varying backgrounds. That allowed a process of selection which stripped the subject of all extraneous elaboration, leaving the primary features which the artist sought to convey. This could only be achieved through a deep understanding of both the structure and its position in the landscape.

For Lowry, to be ordinary and unassuming had the greatest merit. He rarely depicted the grand, the opulent and the admired. Such subjects were rejected; they were more likely to catch the eye of other artists. So it was often the mean street or the plain building which attracted his attention. An industrial town might have fine churches, castles and civic buildings, but it was the mundane terraced house, the cobbled street and the imposing mills which represented its very heart.

Then there was the depressed and the downright ugly. It is quite clear that Lowry sketched in situations and places which would have had no appeal whatsoever for other artists who would have been alienated by the squalor and fearful of the throng. Run-down areas and derelict buildings had a special attraction for Lowry, in particular those which were animated by some peculiar, tragic, comic or everyday incident - an accident, a fight or an arrest.

Lowry was drawn to the unusual and the absurd. His acute sense of observation, married to a wry sense of humour, created a virtue out of lack of proportion, odd architectural design and the sometimes ill-conceived decisions of urban planners. Thus the Tower of St Michael's and All Angels in Irktown is seen to attempt to rival the

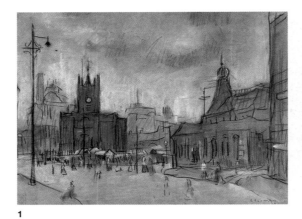

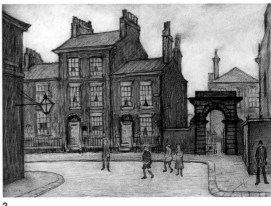

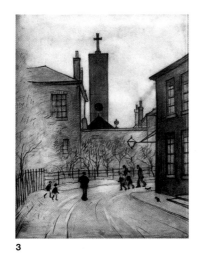

1 *The Flat Iron Market* (c 1925), charcoal, pencil and white chalk, 28.3 x 38.3 cm. Sacred Trinity Church, Salford and the triangular piece of land which gave the Market its local name.
2 *By the County Court, Salford* (1926), pencil on paper, 24.6 x 34.9 cm. The arch can still be seen today. Close comparison of the drawing and the arch reveals that Lowry distorted the vertical scale to give a sense of greater prominence.
3 *The Tower* (1926), pencil on paper, 35.5 x 25.3 cm. A faithful rendition of a Georgian area of Salford known as Leaf Square. The tower, however, existed only in the artist's imagination.
4 *View from a Window of the Royal Technical College, Salford* (1924), pencil on paper, 55.5 x 37.5 cm. A much-changed view, depicted in a wide variety of pencil techniques.

spire of Salisbury Cathedral whilst being on top of a relatively squat church. As portrayed by Lowry, it looks ridiculous; it was just as ridiculous in real life. The artist also selected subjects which were both curious and thought-provoking. A set of steps - where do they lead? Lowry knows the answer, but leaves the observer to guess. Or a hill, like Junction Brow, the steepest in the city of Manchester. What is over the brow?

Other subjects were selected, either consciously or sub-consciously, and later became key features of the composite landscapes - a railway viaduct, the above-mentioned St Michael's, the park, Acme Mill, the flooded River Irwell, gateways of iron or brick ... the list is endless.

It is also clear that some of Lowry's places were chosen as reflections of his inner turmoil deriving from his parents' indifference to his art and the unremitting decline and eventual death of his beloved mother. His isolation and growing detachment mutated real scenes into nightmare visions and once proud but deserted houses into portraits of despair and dereliction.

For all this darkness there is also warmth and light. Lowry often sought out places to provide a suitable backdrop for scenes of enjoyment and celebration. Thus a country fair, rowing regatta or town park highlight the worker at play. The people may look the same as in a typical industrial scene, but here they parade in their Sunday best, relishing rare pleasures.

To the casual observer, Lowry's portrayal of place is merely topographical. This supports the designation of the artist as a mere and minor local artist whose significance, if any, should be assessed in terms of social history rather than art. It encourages, also, the viewer to consider a false reality - if Lowry drew it this way then this is how it must have looked.

This is, however, an almost total misrepresentation. There are, in truth, some very accurate topographical drawings, among them *Flat Iron Market* (1925) and the various 'Views from a Window'. These are, however, more often than not exercises in technique which demand attention to detail. Thus *View from a Window ... Looking towards Salford* (1924) is a faithful rendition, its beauty lying not in the subject but in the versatility of line, shade and form created with just a pencil. There are also commissioned works, which demanded faithful rendition.

In the main though, it is evident that the artist manipulated his seemingly straightforward topographical studies from a very early stage. This was sometimes achieved by simply altering perspective or proportion. In *By the County Court*, for instance, the archway is represented in Lowry's drawing as being higher than it is in reality. And then there is *The Tower*. This drawing was executed in Leaf Square, Salford, an enclave of Georgian housing (long since demolished) which Lowry drew many times in the mid-1920s, populating his studies with ghostly Edwardian figures. But the tower is a complete fabrication. There was no such structure, either in Leaf Square or nearby. A real place has been invaded by an alien structure. To what purpose it is not clear, but the colour and form of the tower contrasts markedly with the gentility of the houses and creates an oppressive atmosphere. Major additions to a 'place' may be fairly rare, but there are numerous examples of the artist omitting buildings

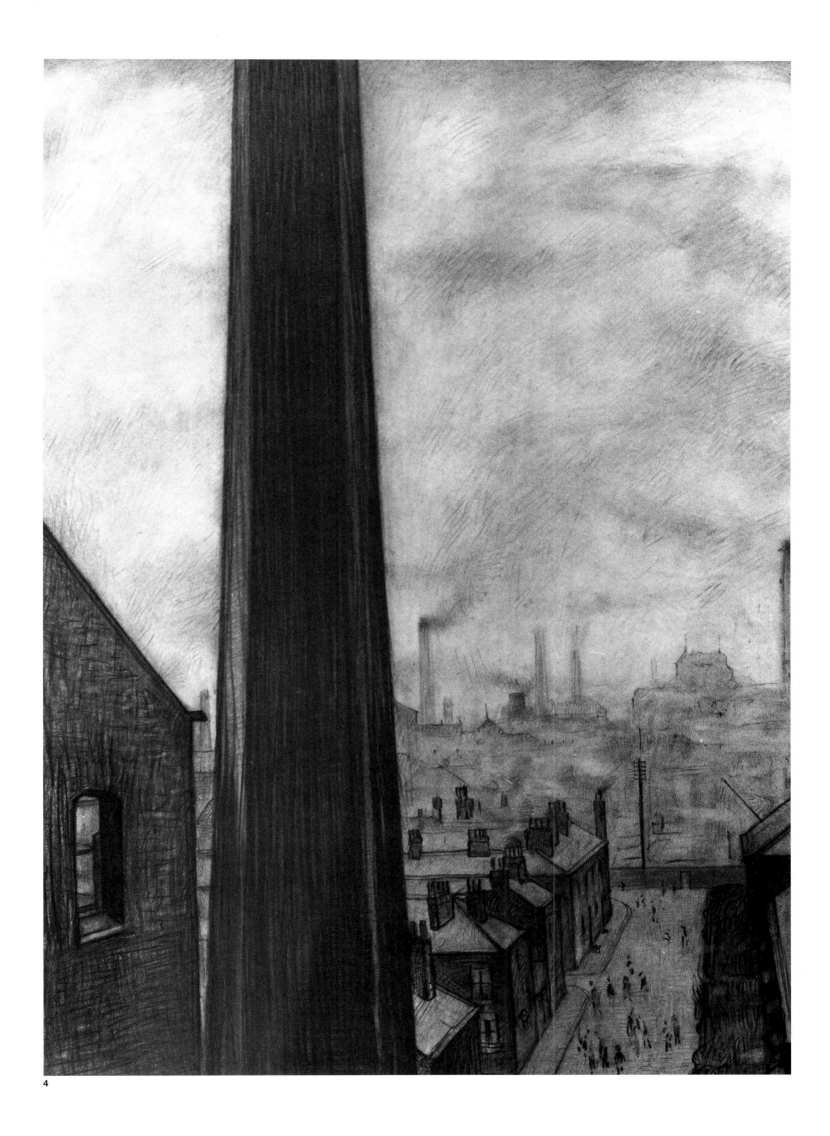

4

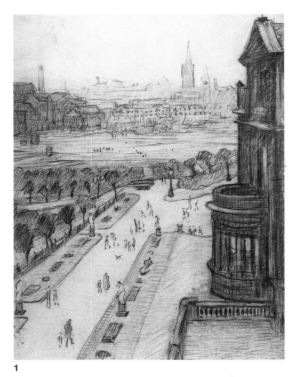

1

1 *View from a Window of the Royal Technical College, Salford looking towards Manchester* (1924), pencil on paper, 55.5 x 37.5 cm. A view encompassing the terrace behind the Museum and Art Gallery, Peel Park, St Philip's Church and Salford Cathedral.
2 *By Christ Church, Salford* (1926), pencil on paper, 35.5 x 25.3 cm. The wrought-iron gateway with the central lamp is a recurring feature in Lowry's work. Was this his initial inspiration?

from topographical works. In other cases, buildings were selectively repositioned. This blatant manipulation of images reached a peak with *Industrial Scene (Ashton-under-Lyne)* (1952) in which Lowry simply redrew the town map for the sake of composition. Those who know the town can recognise it immediately but it is not the real town, it is the view as Lowry saw it in his mind.

Then again, it is all too easy to interpret some of Lowry's best-known images, for example *The Lake* (1937), as completely imaginary. Again, this is a mistaken premise. The infernal vision was based firmly in events and scenes witnessed by Lowry. These ordinary occurrences were then given a much more vivid expression.

L S Lowry's industrial landscape paintings are composites, bringing together buildings, structures and spaces each of which has an origin in one of the thousands of places sketched by the artist. These studies, together with a vast mental storehouse of images, formed an immense catalogue from which the artist could select. Some became favourites and appear in several paintings, others make solitary appearances. Thus a Pendlebury cotton mill might stand next to a house from Manchester and be set against an interpretation of Peel Park in Salford. It mattered little where the image was derived from.

Apart from creating complex compositions which often challenge artistic convention, Lowry also left an ongoing challenge to researchers to identify and locate these many separate images. One particular combination frustrated researchers for many years. A church with a very high tower was often represented in association with a set of swings in a children's playground.

This same church appeared also to be shown on a hill in the far distance of several paintings, linking with a church spire somewhat nearer the foreground.

Was this a real juxtaposition or the artist creating fanciful combinations? There was no obvious resolution. Then, in 1998, a hitherto little-known work, *The Steps, Irk Place* (1928), came onto the market. Here was the very church and the exact same set of swings with a clear location. Regrettably, there are rarely such easy answers to the puzzles set by L S Lowry. Irk Place seemed at first not to have existed. When located, it was found to have no obvious links to the church and swings. However, they had existed and, thanks to the memories of readers of the *Manchester Evening News*, could be found in Ancoats. The title of the painting is, however, erroneous as the real location is in Irk Street. The church had long since been demolished but the set of steps and the playground remain.

But what of the church on the hill? It is clearly not the same church, but a similar configuration can be seen from the former school of art in Peel Park - where Lowry studied for many years - looking towards Bury. There is no firm evidence that this is the view which Lowry used as a background in several works, but it is the most likely candidate.

Industrial Landscape (1925) portrays a complex of buildings and chimneys which could easily have emerged from the artist's imagination. However, it could have been based on a real place, and it was suggested that it featured an ironworks in Wigan. A freelance journalist (and self-confessed Lowry addict), was enlisted to help. An article seeking information duly appeared in the *Wigan Observer*.

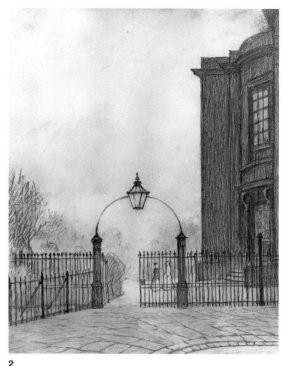

2

Many local people instantly recognised the view and their responses, together with research at Wigan History Shop, gave the painting a belated location.

Other subjects appear easy to locate. *Agricultural Fair* (1949) survives as an annual event in the village of Mottram-in-Longendale. However, it no longer takes place at the site which Lowry recorded.

Sometimes, a researcher solves a mystery. Thus a photographer undertaking a survey of the places Lowry portrayed, located *Corner Shop* (1943). On other occasions, a chance encounter provides elucidation, as when a local historian solved a mystery surrounding *Old Gateway* (1963). This could have been any of the myriad cotton mill or factory entrance gates. But local knowledge once more provided an exact location. Again, *Portrait of a House* (1954) seemed almost impossible to locate until the present owner of the house happened to comment on the painting.

Luck also plays a minor role in tracing Lowry's places. More often, intensive research through local history libraries and museums is required, as the only sources are old maps and specialised knowledge. For each place or image definitely located there are many which still present a puzzle.

The artist scarcely assists research. It is evident that he either forgot names or changed them at whim. Irk Street became Irk Place, Oldfield Road became Ordsall Lane. Other names like Police Street, where he presented an arrest, could easily have resulted from his sense of humour. Furthermore, he did not keep records of where and when he made sketches and many drawings are neither titled nor dated. Even interviews given to newspaper reporters and others are suspect as he gave, more often than not, the answers he believed that the questioner wanted.

Finding out about 'Lowry's Places' becomes a constant process of detection and scrutiny. Most of the places which he recorded are no more; whole districts have been obliterated through demolition and development; memories are fading and Lowry's generation is passing away.

In the pages that follow we have used a mixture of major paintings and drawings of the places we can identify, together with black-and-white photographs from Lowry's day and modern colour pictures of the same location.

In essence, place was paramount to Lowry. It provided both the fundamental components for his work and the background against which he could position his people. Undoubtedly, the most important place in Lowry's art is England's North-West. It was here that he lived and followed his own advice to younger artists to 'paint your own backyard'.

The discovery of Lowry's essential 'place', centred on Pendlebury, came about through family misfortune, but the conjunction of this place and its people with a somewhat unsentimental and curiously insular artist was to inspire works of the highest artistic integrity which convey an unique vision of the life and death of an age.

'We went to Pendlebury in 1909 from a
residential side of Manchester, and we
didn't like it. My father wanted to go
to get near a friend for business reasons.
We lived next door, and for a long time
my mother never got
to like it, and at first
I disliked it, and
then after about a
year or so I got used
to it, and then I
got absorbed in it,
then I got infatuated
with it. Then I
began to wonder if anyone had ever done
it. Seriously, not one or two, but seriously;
and it seemed to me by that time that it
was a very fine industrial subject matter.
And I couldn't see anybody at that time
who had done it - and nobody had done
it, it seemed.'

1 Swinton Industrial Schools.
2 *Swinton Industrial Schools*
(1930), pencil on paper,
27.3 x 36.4 cm.
3 Lowry at St Augustine's
Church, Pendlebury.

Interview with Hugh Maitland

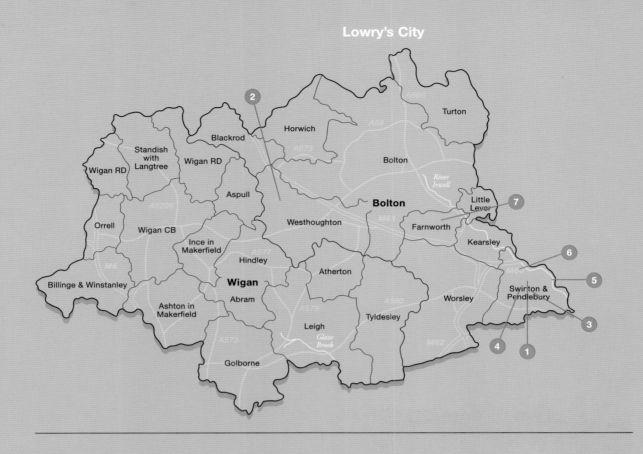

Pendlebury and the West

Not only did Pendlebury provide a home for Lowry for almost forty years, it also gave him his original inspiration. Surrounded by the mills, collieries and factories of this industrialised area, he created his own artistic vision from the monumental structures and their environment.

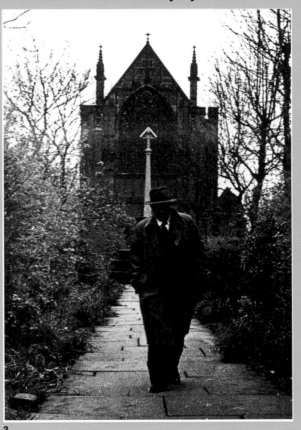

3

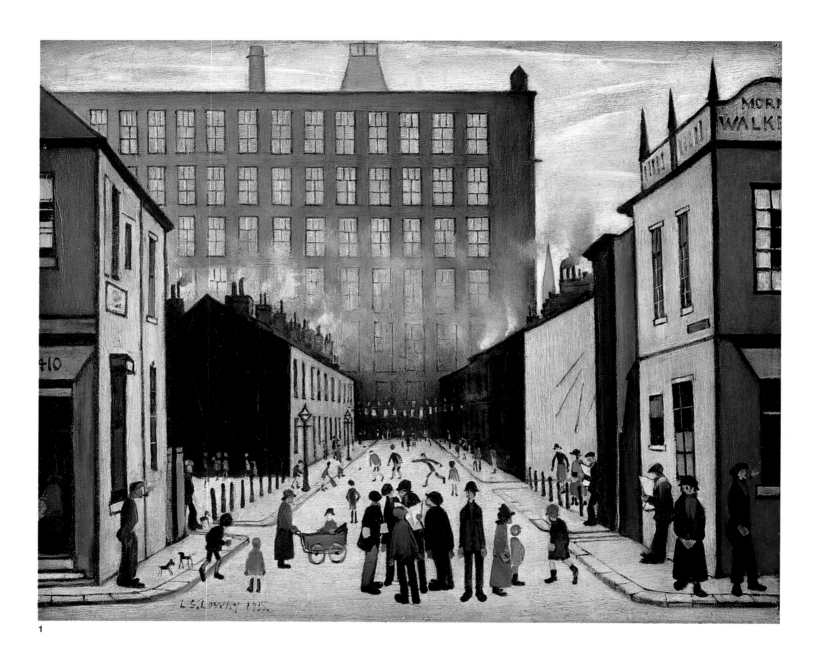

1

2

The Acme Spinning Company Mill opened in 1905. The first mill in the country to be powered completely by electricity, it lacked one of the main features of Lowry's industrial landscapes - a chimney. The building was demolished in 1984.

1 *Street Scene* (1935), oil on canvas, 43 x 53 cm. The Acme Mill building stands in the background; the terraced houses of the mill workers about its giant form. The figures stand under the looming structure, seemingly unaware of the feeling of claustrophobia, as if the walls of the houses are narrowing to crush them. In reality, there was a great sense of community among the inhabitants of these rows, which continued until destroyed by redevelopment.
2 Photograph: site of Acme Mill, Pendlebury. The mill and surrounding terraced houses have been demolished and George Street no longer exists.
3 *Pendlebury Scene* (1931), pencil on paper, 28.3 x 37.8 cm. This drawing was used as the basis for both *Street Scene* and *Mill Scene with Figures*, and for many other works as well.
4 Photograph: looking down Thomas Street towards Acme Mill.
5 *Mill Scene with Figures* (1944), oil on canvas, 43 x 53 cm. Lowry once said of his industrial scenes: 'An industrial set without people is an empty shell. A street is not a street without people, it is as dead as mutton. It had to be a combination of the two - the mills and the people.' True to this adage, Lowry filled his streets with teeming figures.

According to Lowry, Acme Mill was the reason he became interested in the industrial scene. In one of his stories he explains that he had missed a train from Pendlebury: '… as I got to the top of the station steps I saw the Acme Spinning Company's mill, the huge black framework of rows of yellow-lit windows stood up against the sad, damp-charged afternoon sky. The mill was turning out hundreds of little pinched, black figures, heads bent down, as though to offer the smallest surface to the swirling particles of sodden grit, were hurrying across the asphalt, along the mean streets with the inexplicable derelict gaps in the rows of houses, past the telegraph poles, homewards to high tea or pubwards, away from the mill and without a backward glance. I watched this scene - which I'd looked at many times without seeing - with rapture.'

Pendlebury itself seemed, ultimately, to hold the key to Lowry's obsession with the industrial landscape. He was surrounded by mills and factories, they were everywhere. He talked about painting the mills in a matter-of-fact way: 'I did the paintings of factories and industrial workers because I lived on the spot. There was nothing much else for me to paint, you see ….'

But it was much more than that. The industrial scene invaded his life: endless sketching, painting into the night, years spent perfecting each of his works. Lowry found a beauty in the harsh reality of the industrialised community in which he lived and he was compelled to record it.

3

4

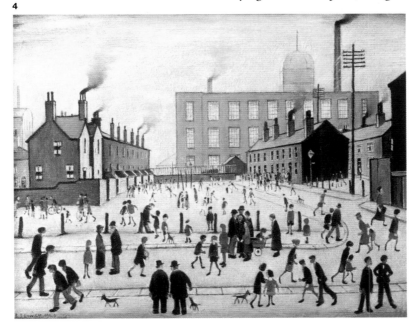

5

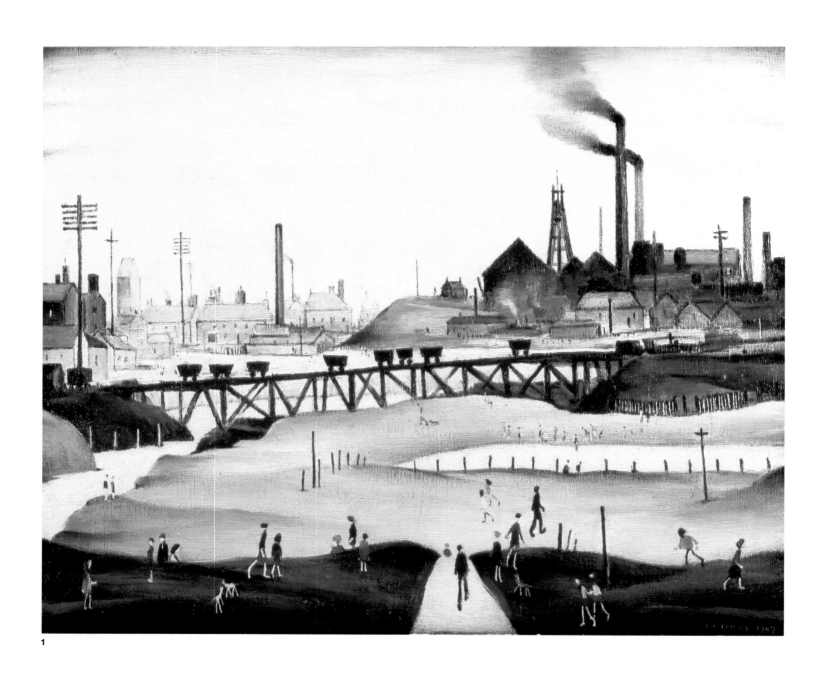

1

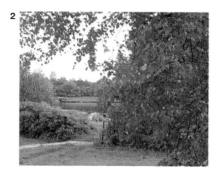

2

The shafts of New Town Colliery were sunk in 1880 and continued production until 1961 when the pit was closed; soon after, it was demolished. It was not only the mills in Pendlebury and its surroundings that were of interest to Lowry; in its colliery he also found a subject to be explored.

1 *Iron Works* (1947), oil on canvas, 51 x 61.5 cm. The figures, which dominate the foreground in so many of Lowry's industrial paintings, here appear as tiny ants moving across a barren landscape. Their relevance to the subject seems incidental.

2 Photograph: site of New Town Colliery, Pendlebury. There is no longer any sign of industry in the area that held the mine. The site is now a residential area. Christ Church remains, but is partially hidden by trees; the reservoir, which stood alongside the colliery, is still there.

3 *Pendlebury Market* (undated), pencil on paper, c 24.5 x 17.5 cm. Pendlebury market was important not only for the town itself, but also for the surrounding areas. This view provided Lowry with an important iconographic image.

4 *View in Pendlebury* (1936), pencil on paper, 28.2 x 38.1 cm. This drawing represents the area of the coal mine, desolate and deserted, its trees lifeless, unable to survive the fetid atmosphere.

5 Photograph: Christ Church, Pendlebury, seen above left in the drawing of Pendlebury Market, and to the left in the painting, *Iron Works*.

6 Photograph: aerial view of New Town Colliery.

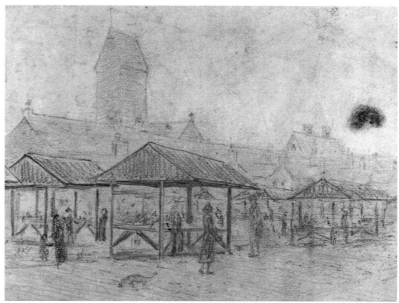

3

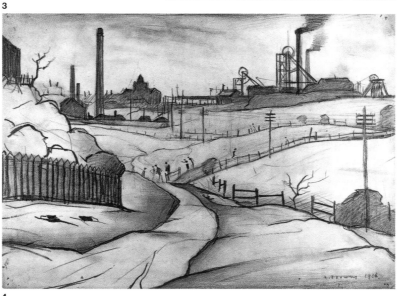

4

This painting depicts the endless conveyor which moved from the colliery to the large coal-grading screen at the Robin Hood Sidings of the London Midland and Scottish Railway. The drawing shows the colliery itself. In the upper-right background of the oil painting stand the winding gear and chimneys of the colliery. To the left is Christ Church, Pendlebury, a church with an unusual lozenge-shaped tower situated near Pendlebury Market.

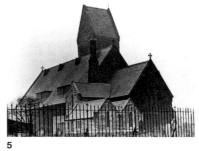

5

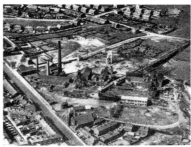

6

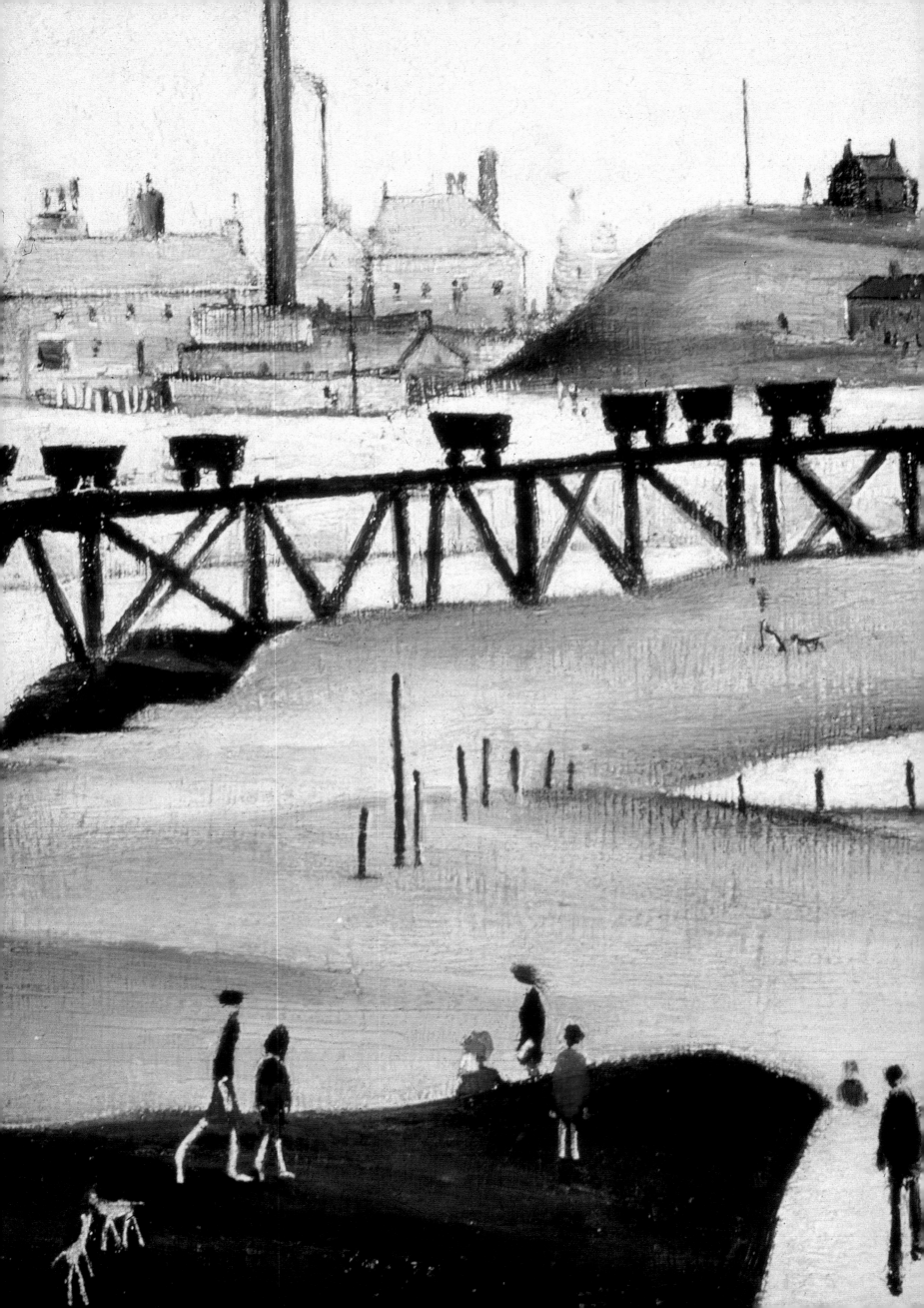

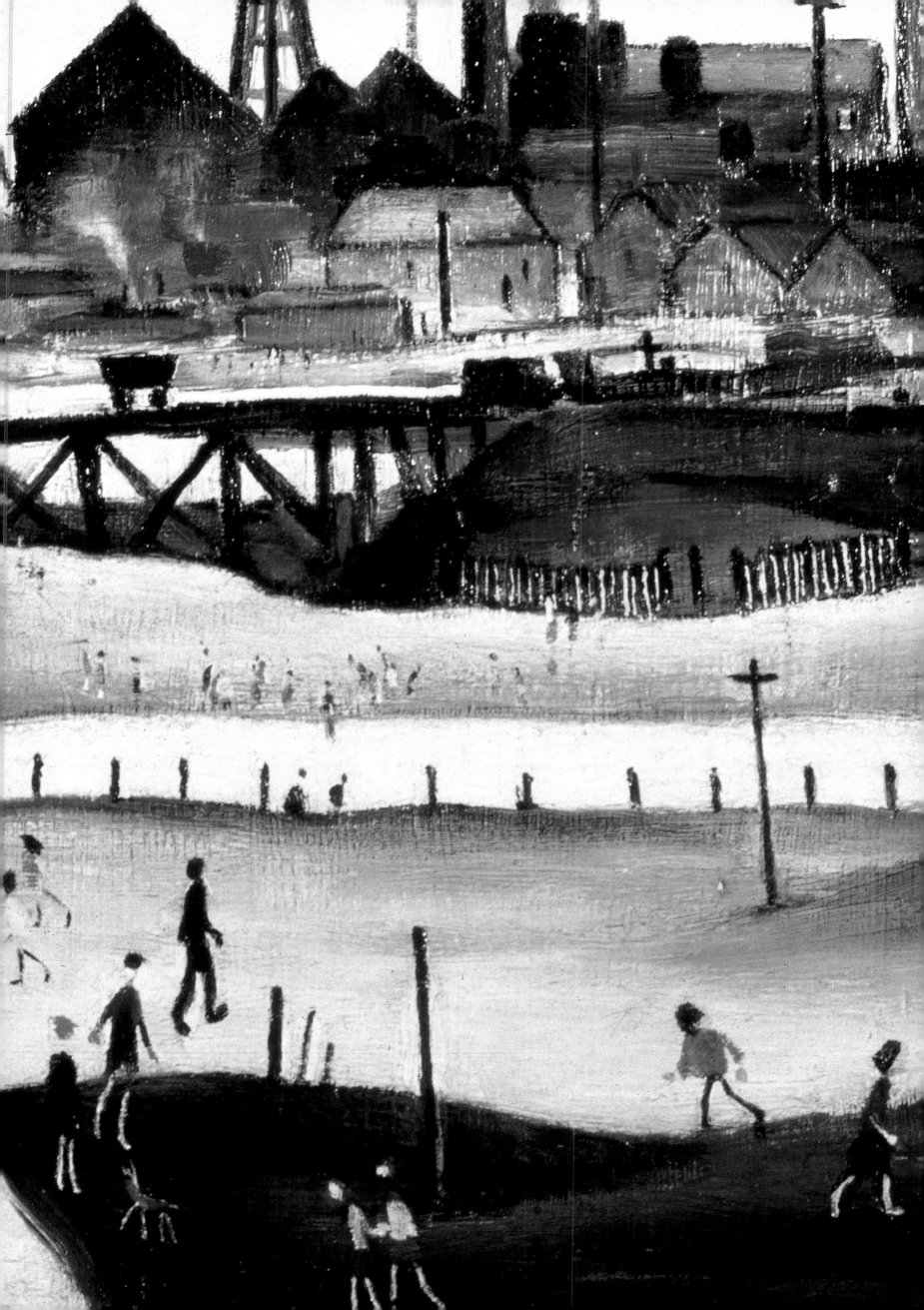

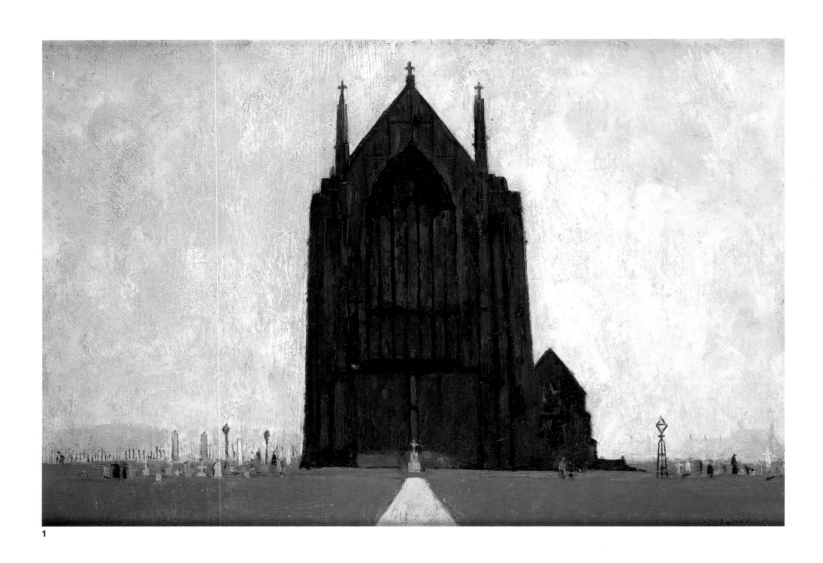

1

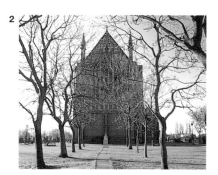

Built of brick with stone facings in 1874, St Augustine's stands in a grassy area surrounded by the buildings of its industrial neighbours. It was a parish of mill workers, people of little affluence.

1 *St Augustine's Church, Pendlebury* (1920), oil on panel, 39.3 x 55.8 cm. St Augustine's Church was close to Lowry's house at 117 Station Road, Pendlebury. Lowry was so taken with this monumental structure that he drew and painted it several times, virtually without any setting.

2 Photograph: St Augustine's Church, Pendlebury. The church is still active but the path leading up to it is lined with mature trees which obscure the building in the summer.

3 *St Augustine's Church, Pendlebury* (1924), oil on board, 37 x 53 cm. Another version of the church. What differences there are lie only in the insignificant background.

4 Photograph: monument to the dead of the Clifton Hall Colliery explosion.

5 *St Augustine's Church, Pendlebury* (1930), pencil on paper, 35.1 x 26 cm. The drawing shows only the church itself. The gate, the houses and the lamps, which appear in the paintings as unimportant additions, have been removed. The image is of a single overpowering structure.

6 Photograph: St Augustine's Church with memorial to its first vicar.

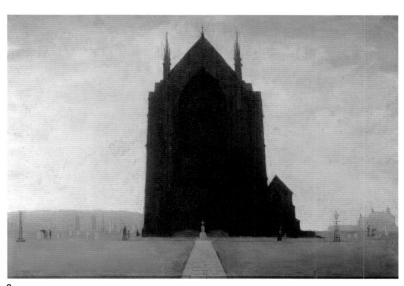

3

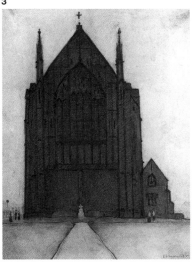

5

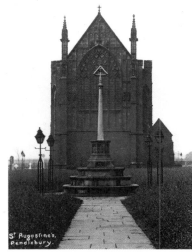

6

Although the church itself is an imposing structure, it does not have the magnificence with which it is imbued by Lowry. What we see is a huge looming black form, which dwarfs everything around it. The church stands in the middle of the painting and alone draws and holds the viewer's eye.

Churches, like the mills, are part of Lowry's rich iconography. But whereas the mills form part of the backdrop of the industrial paintings, the churches take centre stage. Lowry has included in this painting the small memorial situated beneath the east window, which commemorated those killed in the Clifton Hall Colliery explosion in 1885. The size of this memorial emphasises the great structure behind it.

The large memorial to the first vicar of St Augustine's, which stands between the entrance to the grounds and the east window, has been removed from Lowry's painting as it would have served only to detract from the imposing presence of the church.

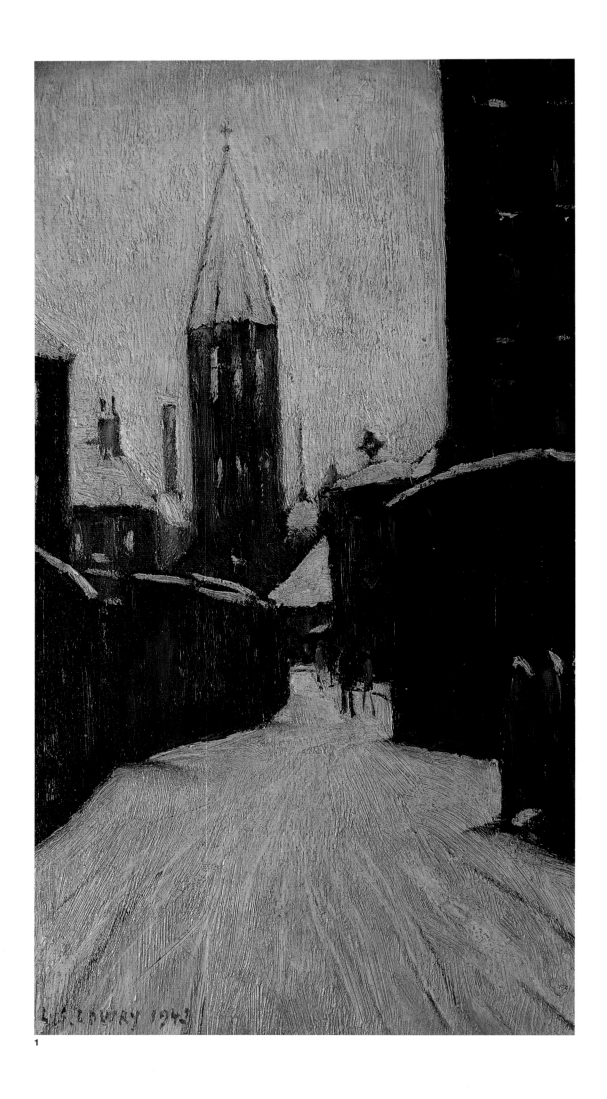

1

Built in 1859 and demolished in 1964, St Mary's Church stood opposite Victoria Park on the corner of Swinton Hall Road near the Albion Mill. The view from the top of Temple Drive, looking down the alley towards the church, is one which Lowry used many times over the years.

1 *Winter in Pendlebury* (1943), oil on panel, 44.0 x 24.0 cm. An important image in Lowry's iconography, St Mary's Church, Swinton looms up into the stark white sky, yet it is dwarfed by the imposing darkness of Albion Mill.

2 Photograph: Site of St Mary's Church, Swinton. The Church has been demolished, but the wall on the left still exists.

3 *St Mary's Church, Swinton* (1960), oil on board, 22.0 x 14.5 cm. This version is much more like the actual scene.

4 *Figures in a Lane* (1936), pencil on paper, 38.0 x 24.0 cm. In this view, as in the 1943 painting, Lowry changed the perspective. Albion Mill takes on an importance which it does not have when seen from the position of the artist.

5 *St Mary's Church, Swinton* (1913), pencil on paper, 20.3 x 11.7 cm. An early topographical sketch on which the painting of 1960 was based.

6 *Albion Mill* (1941), oil on board, 34.9 x 24.1 cm. St Mary's Church is the focal point of the painting, its tower slightly off-centre. Standing to its left is a chimney which Lowry moved to a more prominent position. Albion Mill dominates the right of the painting, and draws the viewer's eye towards the tower.

7 Photograph: St Mary's Church, Swinton.

In all these scenes, from the earliest drawing of 1913 to the paintings of the 1960s, the spire of the church rises above the neighbouring walls.

Although the topography in all the works remains much the same, the emotive content changes. Whereas the early drawings and the late paintings have a feeling of spaciousness about them, the painting *Winter in Pendlebury* from 1943 does not. The buildings, dark and overbearing, seem to enclose the alleyway, the figures almost disappearing within the narrow passage. Using this local scene as a form of expression, Lowry forces the viewer to identify with the oppressive loneliness which he felt after the death of his mother.

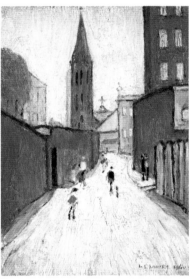

3

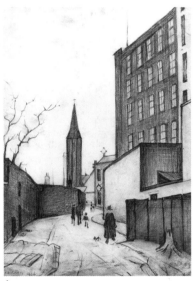

4

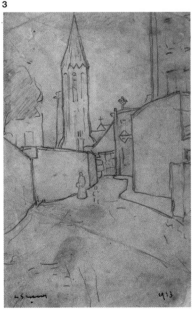

5

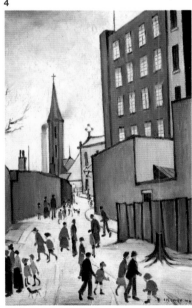

6

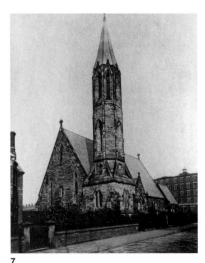

7

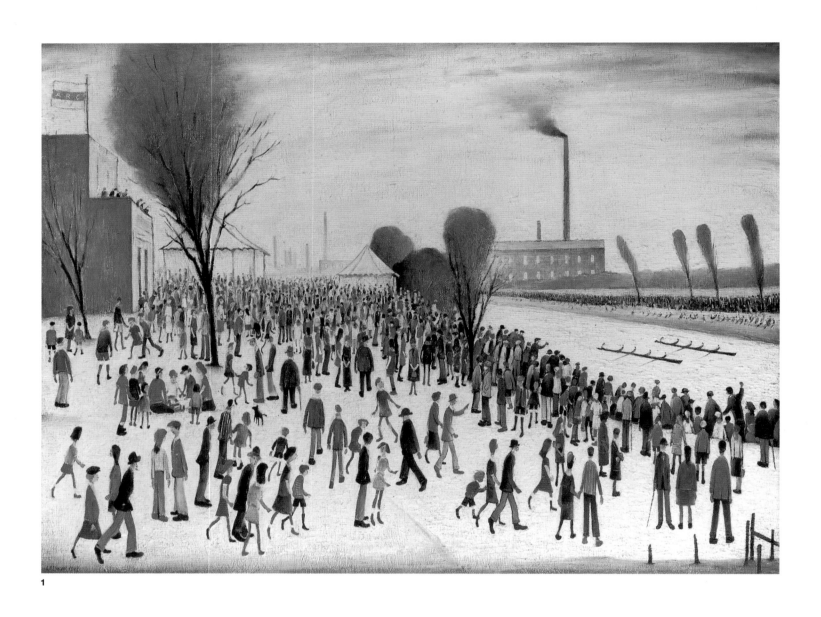

1

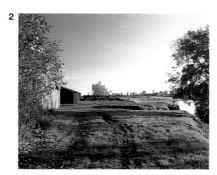

The Agecroft Regatta was an annual fours race between the Agecroft Rowing Club and the Manchester University Boat Club for the Manchester Challenge Cup. In 1948 this event, which brought crowds to the banks of the River Irwell, also brought Lowry.

1 *The Regatta* (1949), oil on canvas, 77 x 102.5 cm. The crowd remained an integral part of Lowry's iconography throughout his life. Myriad activities occur between the figures, which at first seem like a crowd of unrelated people, so adding to the interest of the scene.
2 Photograph: site of *The Regatta,* Agecroft. Although the buildings are as Lowry depicted them, the view would not have been possible given the position of the land and the line of the river.
3 *Agecroft Regatta* (1948), pencil on paper, 37.4 x 26.7 cm. In this sketch of the races, as in the painting, the crowd is the dominant feature. Although many of the figures appear in both representations of the event, Lowry moved, removed or changed them in the later work to create a new composition.
4 Photograph: boats racing on the River Irwell.
5 Photograph: fours race passing in front of the boathouse.

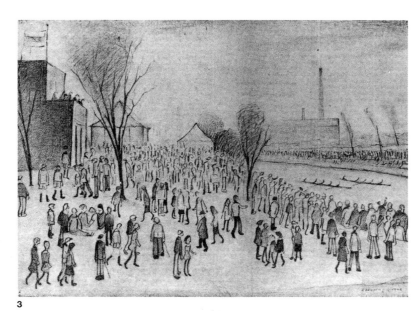

3

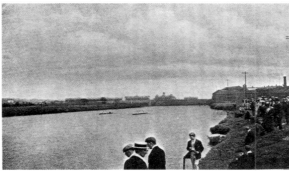

4

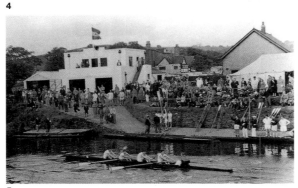

5

The *Manchester Guardian* published a sketch by Lowry of the Committee Ground on Regatta Day, which according to one critic contained lifelike portraits of some of the old members.

The view Lowry chose to paint, looking towards the boathouse, built in 1935, is the location for the beginning of the race. The boathouse stands on the edge of playing fields below Kersal Cell, the site of a monastic building and later the residence of the poet John Byrom. The industrial nature of the setting is characterised by the large building topped by an extremely tall chimney. Although situated in the background, this structure is central to the scene. Lowry does not mingle with the crowd, does not participate in the excitement of the race; rather the eternal observer, he stands at the edge of the activities and records them.

1

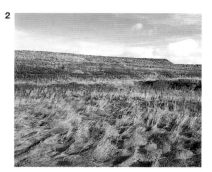

The Kirklees Iron Works, New Springs, Wigan was located just east of the Leeds and Liverpool Canal between New Springs and Hindley, and was locally known as Top Place. The first two blast furnaces of the original iron works were in place by 1858; in its prime there were ten furnaces.

1 *Industrial Landscape* or *Landscape in Wigan* (1925), oil on canvas, 40.5 x 39.6 cm. The people who became the focus of Lowry's later work are missing from this early industrial painting. Instead, the strong verticals of the chimneys occupy the spaces which will later be filled with figures.
2 Photograph: site of Kirklees Iron Works, Wigan. Standing on the site today, it would be difficult to imagine what was once there. Now it is only rough open space with paths through it to form a country walk. The people in evidence are dog walkers and children on bikes.
3 Photograph: Kirklees Iron Works, New Springs, Wigan.
4 Photograph: aerial view of Kirklees Iron Works, New Springs, Wigan.

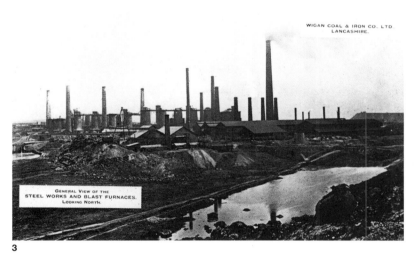

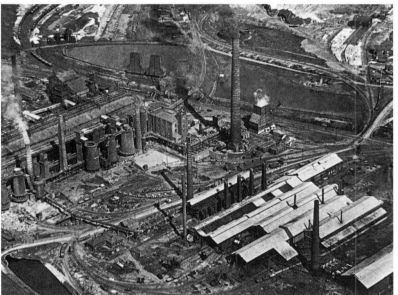

By the end of 1888, the first steel was produced, and the associated rolling mills were opened in the following year. The site was noted for having one of the tallest chimneys in the country - known as Top Place Chimney - which extracted poisonous gas from the furnaces.

The Iron Works, which had become the Wigan Coal and Iron Company Ltd, closed in 1934. Only the workshops remained after the demolition of the furnaces and chimneys, and these were used as a machinery store until the 1980s.

In this early painting, created before he began to use a white background, Lowry represented the buildings and chimneys of the iron works along with a great slag heap which holds the residue of the smelting process. There is little detail in the structures themselves; the overall impression created by the colours and texture of the paint is of a massive industrial complex filling the air with dark noxious fumes.

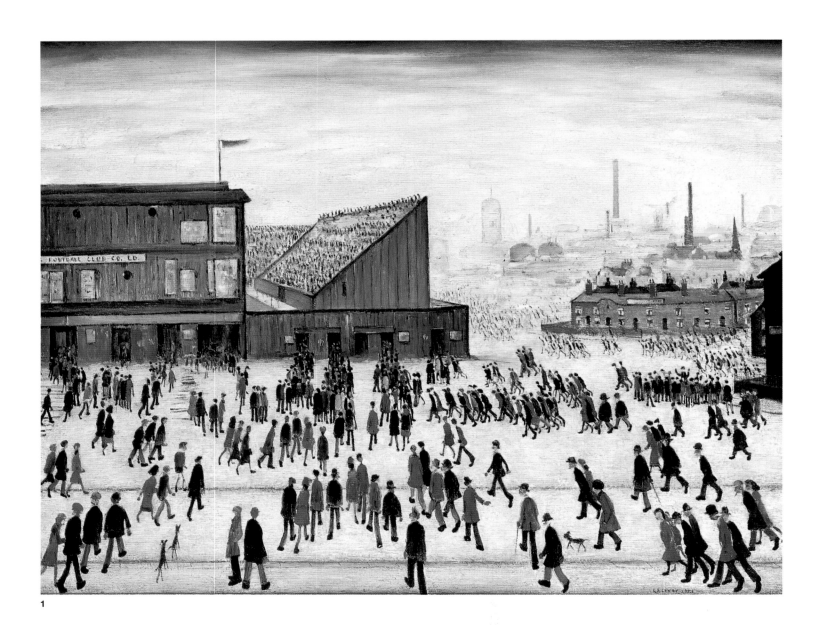

1

2

Burnden Park was the home of Bolton Wanderers Football Club, which from 1934-64 was one the top ten clubs in England and in 1953 won the Cup Final. The stands were built in 1895, and had 8,000 seats; the record attendance was just under 70,000. Because of their dangerous condition, the stands were demolished in 1998 and a new stadium was built at another site.

1 *Going to the Match* (1953), oil on canvas, 71 x 91.5 cm. In 1953, Lowry entered this painting in a competition sponsored by the Football Association. It was one of the winners. Lowry made several changes from the original sketch. In the painting, the stands are given a more prominent role; the tiny houses in the background have been moved forward and are represented in greater detail; a dome has been added to the tower in the centre background. This dome, found in virtually all of Lowry's mill scenes, is purely fictional.
2 Photograph: site of Burnden Park, Bolton. The terraced house on the right is still there, but not as Lowry depicted it. The view is from above. Did Lowry, like the photographer, stand in the upstairs room of the café opposite?
3 *Going to the Match* (1953), pencil on paper, 19 x 24.7 cm. This sketch of the Burnden Park stands forms only the basis for the finished painting.
4-5 Photographs: fans on the terraces at Burnden Park, Bolton.

3

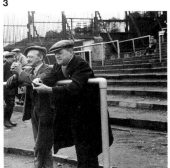

4

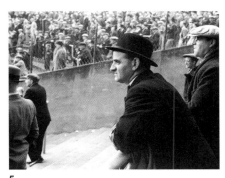

5

Lowry was fond of football and attended Bolton Wanderers matches. He used to walk from his home in Station Road, Pendlebury, to the club's ground. To the casual observer, the focus of activity lies within the ground itself: the players on the field and the excitement shown by the supporters. However, Lowry chose not to represent this aspect, just as he chose not to represent the interiors of mills, but rather the crowds moving towards the massive structure which will contain them.

Here the fans stride purposefully towards the stands; there is no communication between individuals. What Lowry has portrayed is the loneliness within the group. This view of the crowd is characteristic of all of Lowry's industrial paintings. 'But I do contend,' he once said, 'people say that all the figures that I've done now are of the Thirties... groups... I maintain - from observation - that if you see a crowd of people coming from a football match, they look exactly the same as they did fifty years ago. I'm convinced of that.'

While the stand takes the place of the mill, the physical elements of the industrial towns - chimneys, mill tower and church - have all receded far into the distance. Only the row of terraced houses on the right of the painting acts as a compositional arrow and boundary to the action.

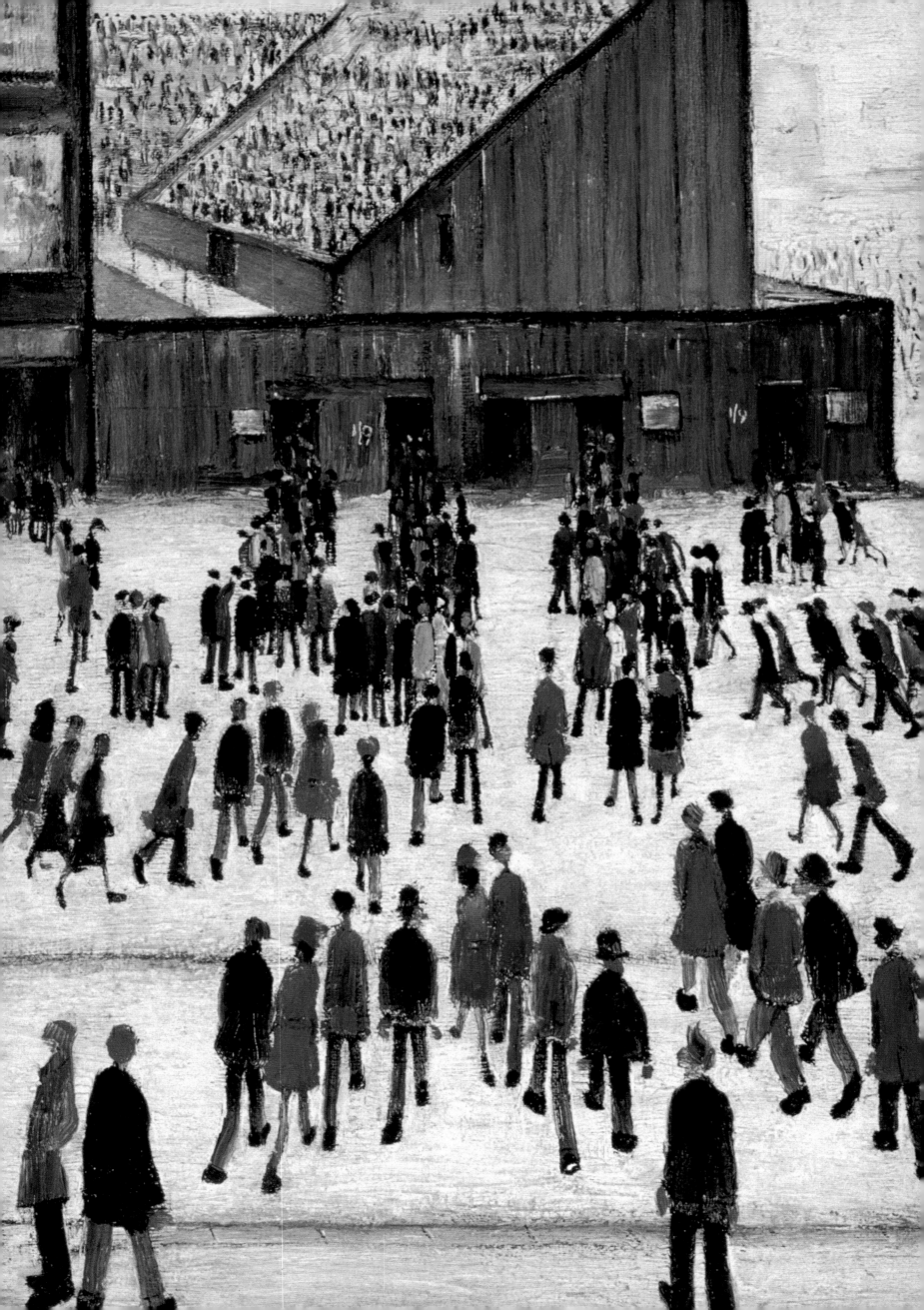

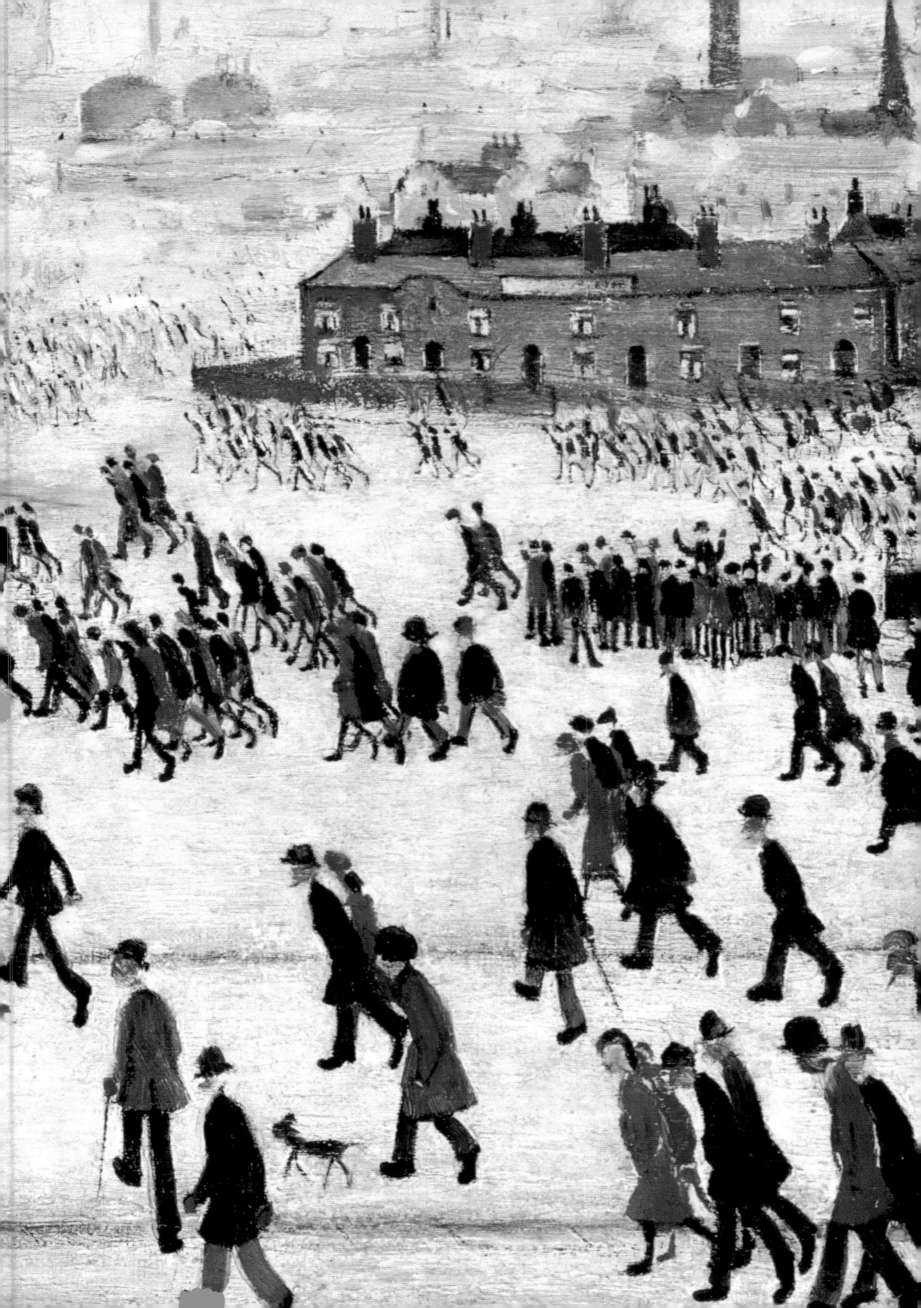

'After a time he (Ted Frape, Curator of Salford City Art Gallery) wanted me to do some of the buildings in Salford that might not last for a very long time … There are pictures of churches - half a dozen churches that have now gone - and recreation grounds … I did a lot of things. I didn't get much for it, but then nothing was bringing much in those days at all.'

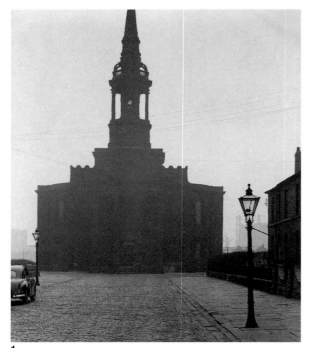

1

2

1 Photograph: Christ Church, Salford, looking down Acton Place.
2 *Christ Church, Salford* (1956), pencil on paper, 33.0 x 23.7 cm.
3 Photograph: Lowry in a street in Salford, c 1957.

Interview with Hugh Maitland

Salford

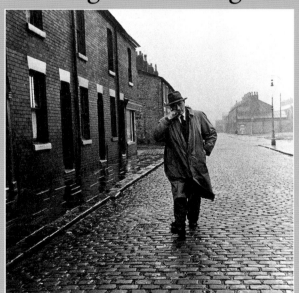

3

In Salford, Lowry attended art school in a Victorian building overlooking Peel Park which borders the River Irwell. Here he learned to paint with his characteristic white background. And here he found further inspiration: the river, the park, and the buildings close to them, the Georgian terraces and the churches.

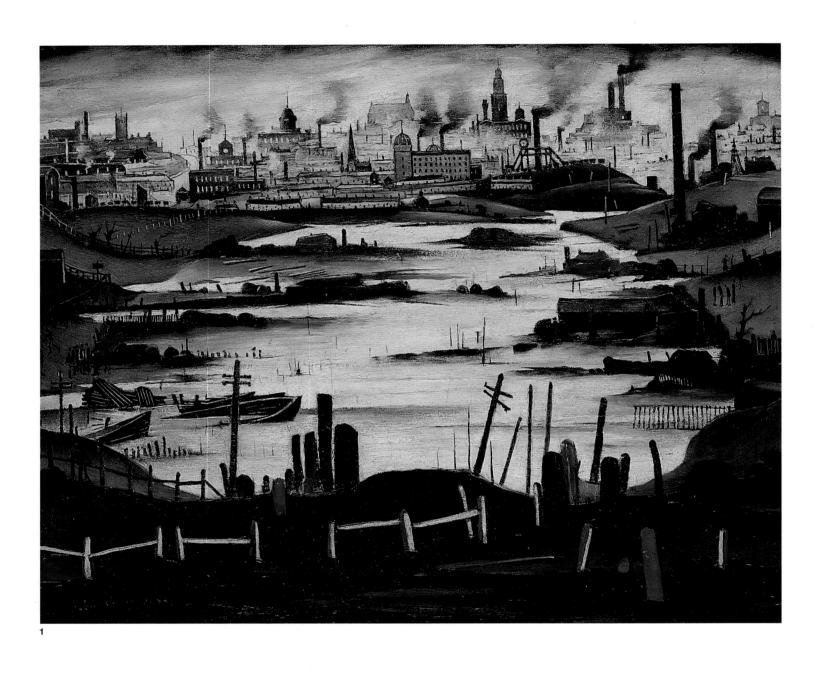

1

❶ The Lake

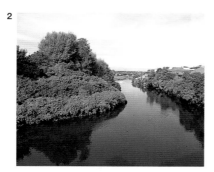

2

The River Irwell often flooded in winter. The scene of this flooding at the Adelphi, which Lowry first drew in 1924, provided him with a subject that he was to use over and over again in his composite paintings.

1 *The Lake* (1937), oil on canvas, 43.4 x 53.5 cm. The tiny figures in this bleak scene of devastation are given no colour, no detail, but from the position of their bent heads and bodies, painted with single strokes of the brush, their sense of despair is clearly conveyed as they look out at the water or turn their backs on it.
2 Photograph: River Irwell at The Crescent. There is little activity, as the site of the factories and other industrial buildings is now a nature reserve.
3 *River Scene* or *Industrial Landscape* (1935), oil on plywood, 37.5 x 51.4 cm. Painted two years before *The Lake*, *River Scene* has the same feeling of despondency which permeates the later work. Even the paint, thick and opalescent, mainly white and black, adds to the sensation of despair.
4 *River Scene* (1942), oil on plywood, 45.5 x 63.4 cm. Lowry has taken the 1924 drawing (below) and filled an imaginary landscape with the factories, churches and houses that had become part of his store of images.
5 *River Irwell at the Adelphi* (1924), pencil on paper, 35.5 x 52.3 cm. A topographical study of the Irwell.
6 Photograph: River Irwell in flood.

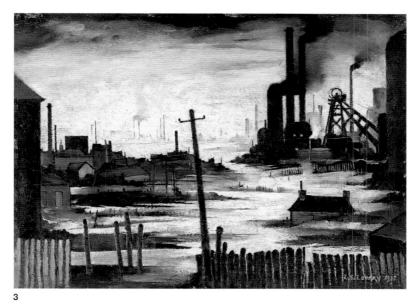

3

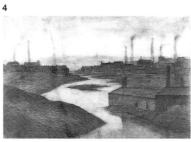

4

5

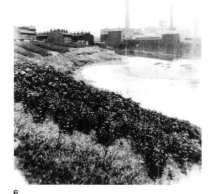

6

Certain elements are essential to all of these works: the great expanse of water with a small island set in its midst, the insignificance of the people, and the industrial encirclement of the river. Because of the arrangement of these components, it is impossible to locate Lowry's point of view.

In the mid-1930s, Lowry's mother was bedridden and he had to spend much of his time, when not at work, catering to her every whim. In *The Lake*, as in so many of the paintings produced during this period, Lowry expressed his feelings by constructing a scene of desolation.

In *River Scene*, which depicts the same subject, Lowry presents the viewer with questions. Are the people in the boats being rescued? Or are they enjoying an afternoon out? Are the people at the edge of the river waiting to take out one of the empty boats? Or have they just disembarked after having been picked up from the ever-rising water? There are, of course, no answers. In these works, Lowry used the river as an expression of his own feelings and his own doubts.

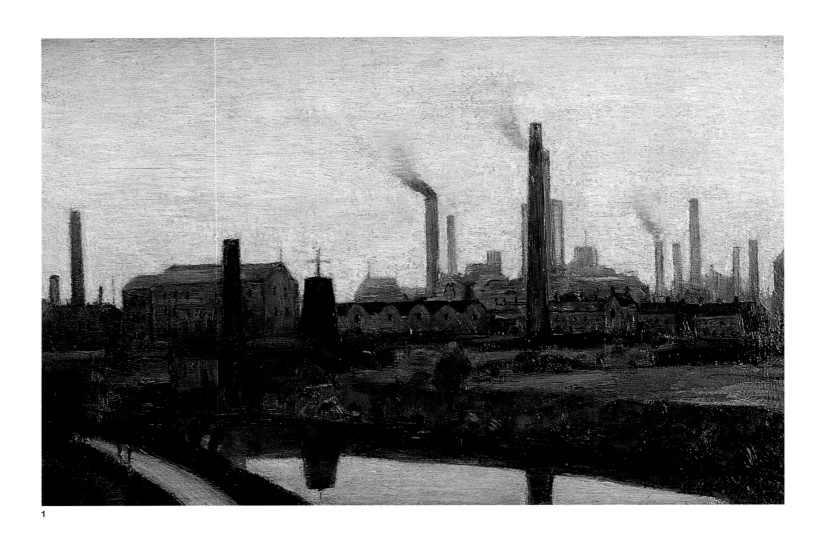

1

The River Irwell is one of the most important of Lowry's subjects. It forms a loop moving along Peel Park, across the area of the Crescent and down the Adelphi section of Salford towards Manchester. Lowry made many topographical drawings from both sides of the river near the Adelphi.

1 *The River Irwell at Salford* (1947), oil on panel, 28.5 x 43.8 cm. A topographical view from Peel Park to the industrialised bank of the River Irwell. Note the reflections in the water. It is likely that this painting is earlier than the date given to it.

2 Photograph: River Irwell at The Crescent. Where Lowry stood is no longer an open view. It is the Adelphi campus of the University of Salford, and a pub. There is no industry, but the path along the river on the Peel Perk side is still there. In the background is the steel of the railway viaduct, a structure that Lowry left out of his work.

3 *River Irwell at Salford* (c 1924), pencil on paper, c 52.5 x 37.0 cm. Lowry kept his early topographical drawings so that the images could be used in his later work, either with considerable modification or as a whole.

4 *A River Bank* (1947), oil on canvas, 69.5 x 90.0 cm. This painting is a radical departure from the actual scene. Note that the reflections in the early drawings and paintings have been removed.

5 *A View of the River Irwell from Peel Park* (1924), pencil on paper, 25.0 x 34.5 cm. Another view from the bank of the river at Peel Park, from which the painting *River Irwell at Salford* was drawn.

6 Photograph: River Irwell seen from Peel Park.

The river flows close to the Salford School of Art (now the Peel Building of the University of Salford), and Salford Art Gallery. This painting shows the side of the river facing Peel Park. In it, Lowry has included the most distinctive of the topographical features of the scene: the windmill, which was built between 1831 and 1848. It was used to pump water out of the polluted river and into large reservoirs where the sediment could settle; the relatively clean water at the top was used by the nearby dye works. It was demolished between 1949 and 1955.

Not content with a realistic rendition of this site, Lowry painted a topographical/composite version. The east side of the river is accurately rendered, but the river itself has undergone a transformation. It is no longer a narrow stretch of water navigable only by small boats, but a large body capable of accommodating the large ships that can be seen floating in it. The park, on the other side of the river, has also been changed from a rural setting to an industrialised site.

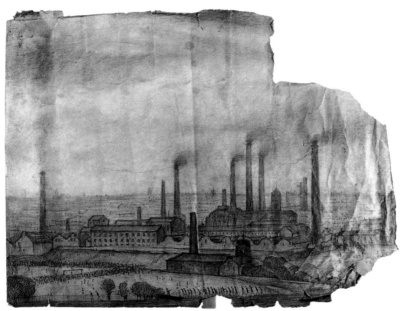

3

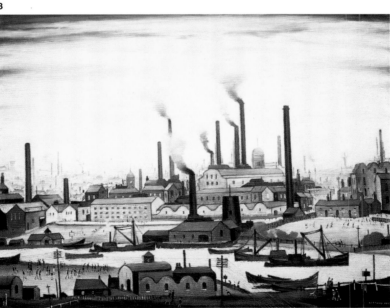

4

5

6

39

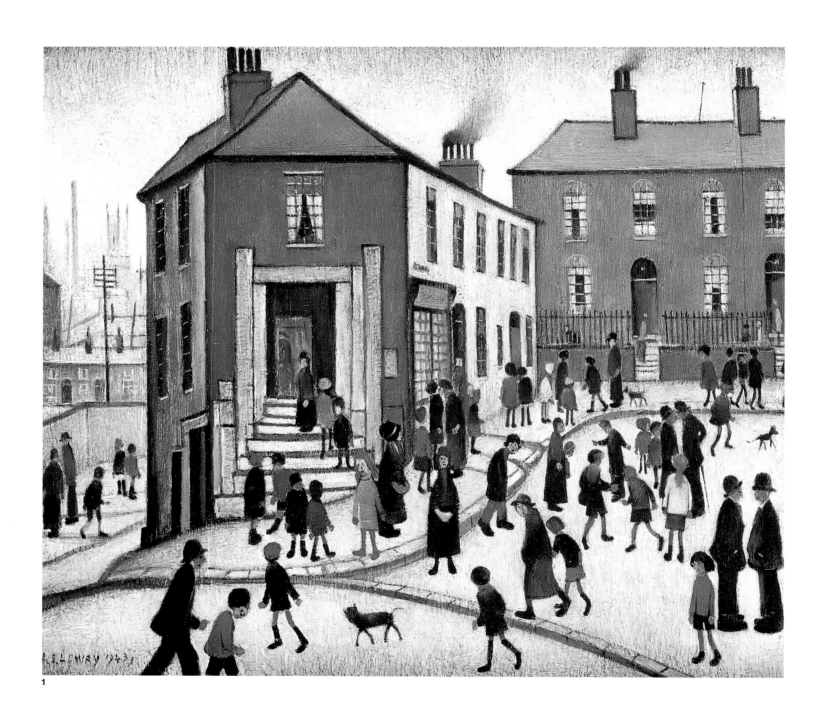

1

Built in the 1830s, the houses in Islington Square were of a reasonable size in a pleasant environment. They were built for the well-to-do on the outskirts of the industrial areas of Manchester and Salford. It is unlikely that number 12 was originally a shop but rather one of the houses of the square.

1 *The Corner Shop* (1943), oil on board, 43.0 x 51.0 cm. As in many of Lowry's works, the perspective of this painting has been altered for the sake of the composition.

2 Photograph: site of Islington Square, Salford. The buildings have all been demolished and the landscape totally transformed. There is now a tower block, and a children's playground is on the site of the square itself. The position of the shop was located only by reference to the railway viaduct and adjacent street.

3 Photograph: Islington Square, Salford.

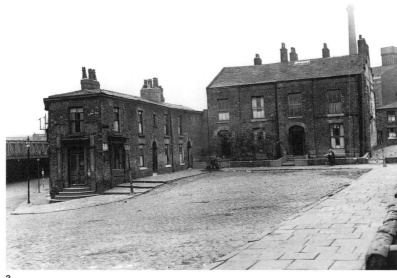

3

With the expansion of industry and the movement of the people who worked in it, the square began to deteriorate and a shop was established.

The most famous inhabitant of the square was Frances Hodgson Burnett, the author of *Little Lord Fauntleroy*, *The Secret Garden* and other books. She lived at number 16 from the mid-1850s to the mid-1860s. She observed, just as Lowry did, the factory workers as they passed by: '… see the factory people streaming past, and hear the young women in tied aprons and with shawls over their heads…' and like him was fascinated by them.

The corner shop would have been a place for meeting and gossip, where people congregated in groups to pass the time of day. In this painting, the shop acts as a focal point, but only for the figures which stand apart from one another.

As with many of the industrial scenes Lowry has portrayed, this view centres around activity; and, as in them, there is little or no communication between the actors.

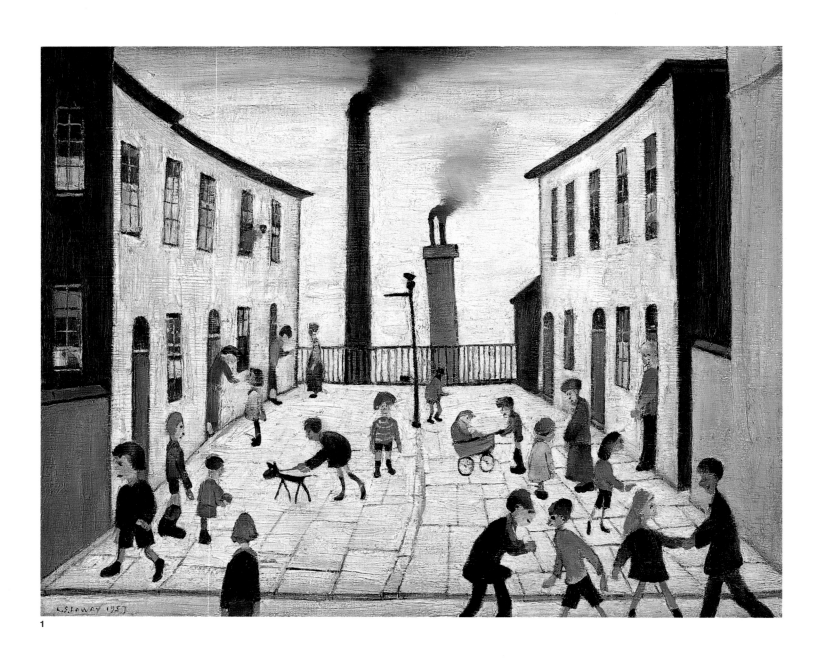

1

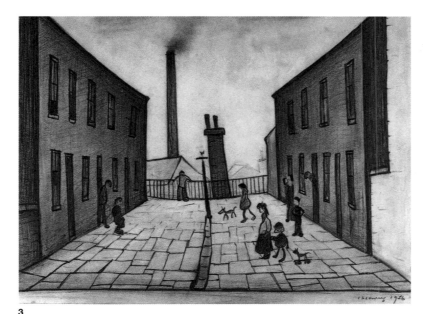

2

Francis Terrace, built in the 1850s, was like many other terraces which filled the area on the east side of the River Irwell in Salford. Built of brick, they comprised 'two-up, two-down' houses with back yards. In the mid-1950s, redevelopment was about to begin. The Salford of the past would be no more.

1 *Francis Street, Salford* (1957), oil on canvas, 40.0 x 50.5 cm. A not unusual street in Salford, flagged and self-contained, and overlooking the street below. When compared with the drawing on the right, it becomes clear that Lowry used his imagination here and changed several details: a building is missing, doorways have become rounded, a roof lowered.

2 Photograph: site of Francis Terrace, Salford. The terraces have been demolished and replaced by new terraces, but the adjoining streets remain the same.

3 *Francis Terrace, Salford* (1956), pencil on paper, 25.3 x 34.9 cm. This drawing was most likely developed from a sketch made on the spot. Lowry considered drawing as important as painting, and it is evident that this work has been finished with the same care and attention to detail as the painting.

4 Photograph: Francis Terrace, Salford.

3

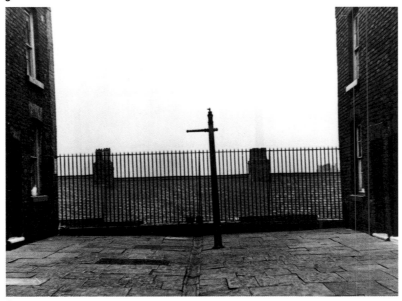

4

The aftermath of the bombing and the deprivation of the local population meant that great changes were needed.

Before the area was destroyed, Lowry was commissioned by the Curator of Salford Art Gallery, Ted Frape, to record the locality around the gallery. Francis Terrace was one of the subjects Lowry chose for his commission. In front of and below the terrace stood another row of terraced houses, and an engineering works stood behind the row on the right.

Although the scene is recognisable, Lowry substituted a tall factory chimney belching smoke for one of the two chimneys on the houses below, and elongated the other one. The roofs on which the chimneys sit have been eliminated completely. From this one can fully understand that for Lowry there was no reality beyond his own vision. Yes, he has represented Francis Terrace, but only in so far as the scene allowed him to pursue his own interests. The terrace was demolished in 1959.

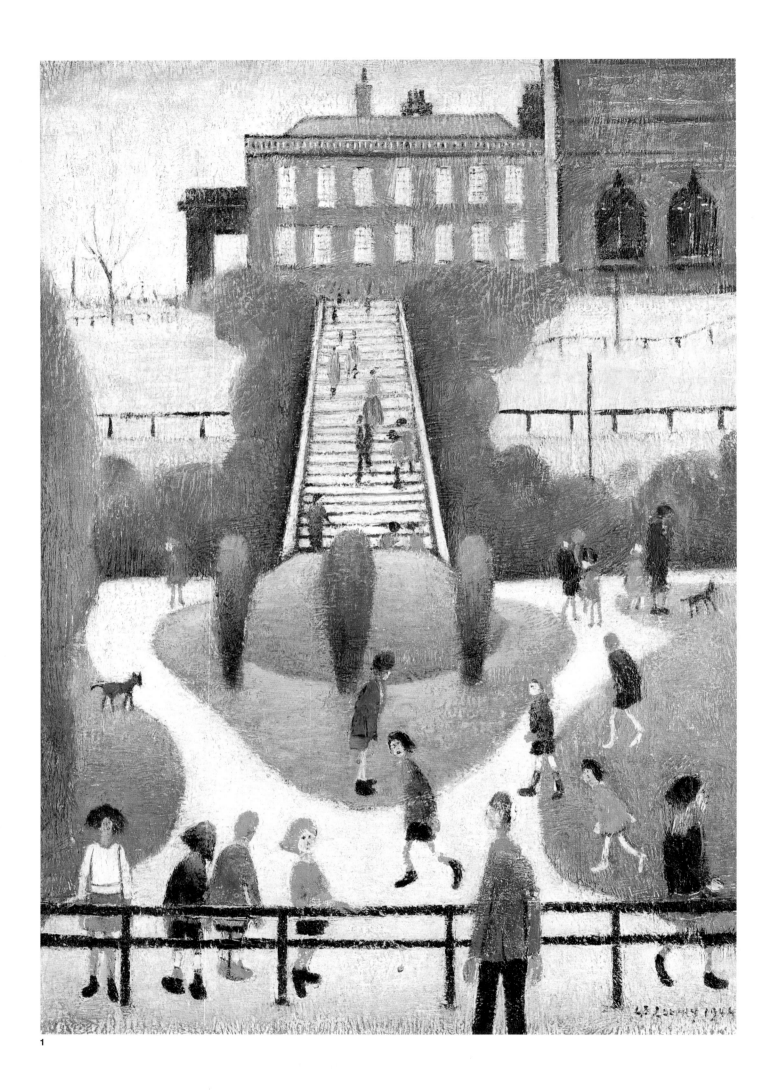

1

Lark Hill Mansion, situated in Peel Park, was built in 1792. The Lark Hill estate was purchased for Salford Borough Council in 1846 by public subscription and became one of three public parks opened in the same year in Manchester and Salford.

1 *Peel Park, Salford* (1944), oil on canvas, 51.0 x 35.5 cm. By the time this painting was done, this scene, which appears topographically correct, no longer existed. The mansion sitting at the top of the steps was demolished in 1936.

2 Photograph: site of Lark Hill Mansion and the steps in Peel Park. The mansion is demolished but the site retains much of its original state. The path configuration is the same and you can still see half of the original steps up to the area that had been the terrace. The museum is now surrounded by the University of Salford.

3 *The Terrace, Peel Park* (1927), pencil on paper, 26.0 x 35.8 cm. The terrace at the rear of the Art Gallery, like all other aspects of Peel Park and its buildings, long held Lowry's interest. This carefully worked drawing shows the relationship between the park and its industrial setting.

4 *Peel Park Sketch* (c 1927), pencil on paper, 19.4 x 11.5 cm. A sketch done at the scene, it shows the salient details necessary for transfer to the more finished work.

5 *The Steps, Peel Park, Salford* (1930), pencil on paper, 19.4 x 11.5 cm. When Lowry produced this drawing, the overall picture was much as he had represented it. Lowry, however, was not content with the image as he saw it, but has added the figures in the foreground. The man standing on the path, staring out at the viewer, is common in Lowry's work; unlike the figure in the painting who appears to look longingly at the scene, this person turns his back on it.

6 Photograph: Peel Park, Salford from the terrace of the Art Gallery.

7 Photograph: the terrace, Peel Park, Salford.

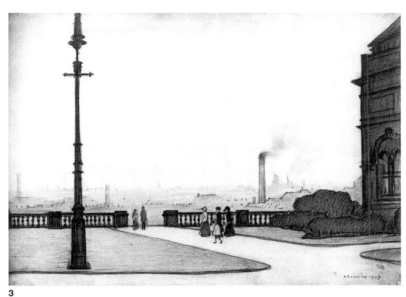

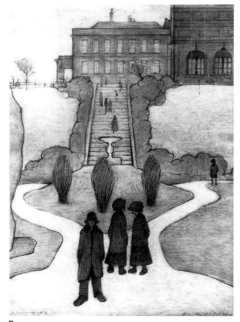

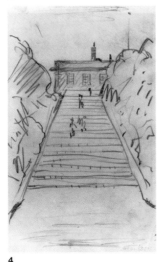

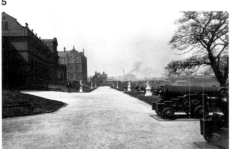

The park was named after Sir Robert Peel, the Prime Minister, who was born in Bury in 1788. The mansion, as part of the estate, became a museum and the first unconditionally free municipal library with the passing of the Libraries Act of 1850. An addition, at the north end, was built in 1853. Lowry absorbed the rich material provided by the park, as he did that of the River Irwell at its boundary.

Peel Park, Salford shows the mansion and north extension looking up the steps from the park. But this painting, like so many of the others Lowry produced, is an image of isolation. Before a fence, children stand on a pathway or wander over the grass around which it curves. They stare at the lonely figure standing behind the barrier. Who is he? Perhaps the artist himself.

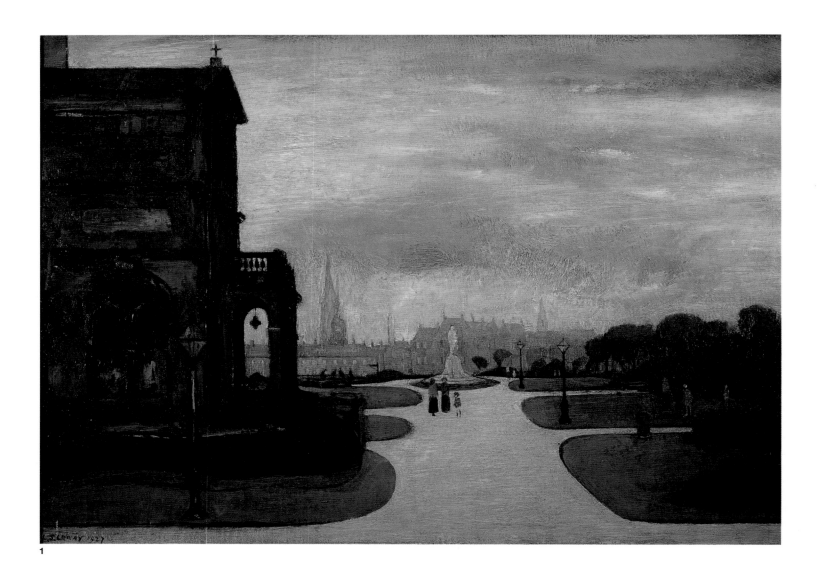

1

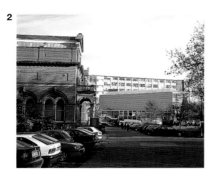

Built in 1878, this portico and entrance lead into the third extension to the Royal Museum and Library, now Salford Art Gallery, Museum and Local History Library. The building faces the Crescent, and is overlooked by the Royal Technical College which housed the Salford School of Art.

1 *Peel Park, Salford* (1927), oil on board, 35.0 x 50.0 cm. Painted the year before Lowry developed his characteristic white background, one can see how the image and its ground tend to merge.

2 Photograph: the Art Gallery and Museum, Salford. The portico still stands but the view has radically changed because of the position of the Maxwell Building of the University of Salford.

3 *Peel Park Sketch* (1920), pencil on paper, 11.4 x 19.0 cm. This view from the Royal Technical College shows the portico of the Langworthy Wing of the Royal Museum and Library, and, at far left, the Victoria Arch.

4 *Peel Park Sketch* (1919), pencil on paper, 19.4 x 10.7 cm. Visible in the background are Salford Cathedral and St Philip's Church, which stand on the other side of the river to Peel Park.

5 *Peel Park Sketch* (c 1927), pencil on paper, 20.0 x 12.0 cm. One of the many drawings of Peel Park, including the ones on this page and on page 45, which Lowry did in his sketch books. It was used for the painting opposite.

6 Photograph: the portico of the Langworthy Wing of the Library, Art Gallery and Museum.

3

In the distance can be seen St Philip's Church and the spire of Salford Cathedral. This is a view that Lowry would have had from the window of the art school and, as with so many of the images he felt he had to record, he spent time sketching it, both as an overview and in detail. The Art Gallery was important to Lowry and he spent much time visiting its galleries, a practice which was to continue until his death.

6

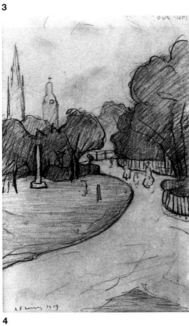

4

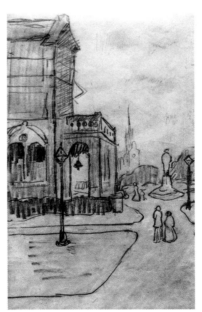

5

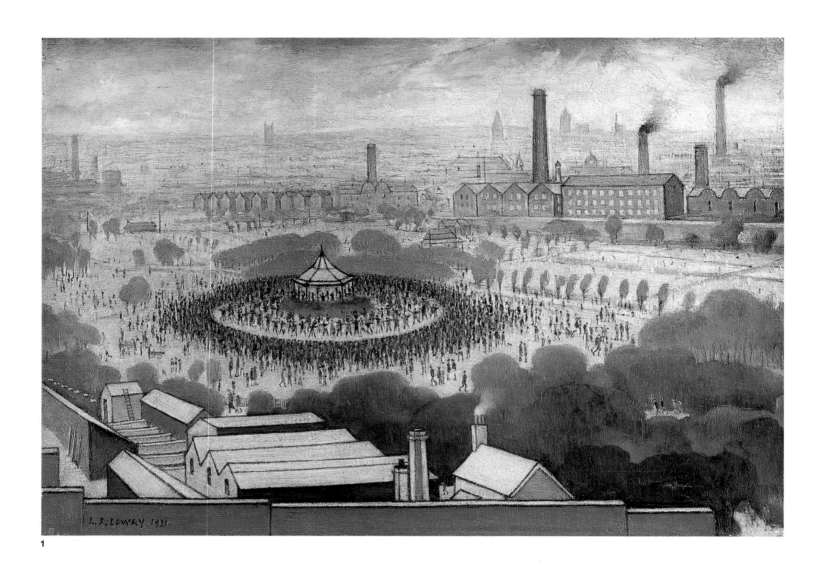

1

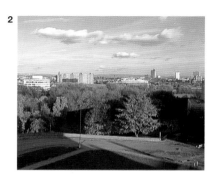

Standing in Peel Park behind Salford Museum, Art Gallery and Library, the bandstand, which was built in 1902 and demolished in 1965, was important for the recreation of the residents of the city, at a time before universal radio and television.

1 *The Bandstand, Peel Park, Salford* (1931), oil on canvas, 43.2 x 62.2 cm. This topographical view across Peel Park displays Lowry's artistic vision perfectly: the park with its trees and greenery is incidental to the milling crowd at the centre of the scene which is almost totally enclosed by the buildings of industry.

2 Photograph: site of the bandstand, Peel Park. The bandstand no longer exists and the skyline has changed with old buildings demolished and new ones built to take their place.

3 *The Park* (1946), oil on canvas, 38.0 x 80.0 cm. A more comprehensive view of Peel Park in its industrial setting.

4 *Bandstand, Peel Park, Salford* (1925), pencil on paper, 36.5 x 54.6 cm. Created six years before the painting, this work has been drawn with exquisite care. Every detail and nuance of the scene has been depicted.

5 *Bandstand, Peel Park* (1928), oil on board, 29.2 x 39.2 cm. Lowry has moved his vantage point down from the balcony of the Art Gallery and into the park itself. Here he looks towards Lark Hill Mansion.

6 Photograph: view of the bandstand in Peel Park, Salford.

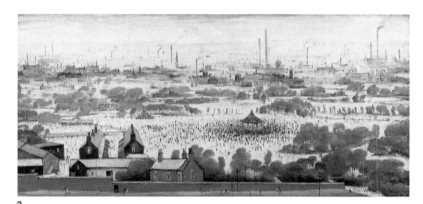

3

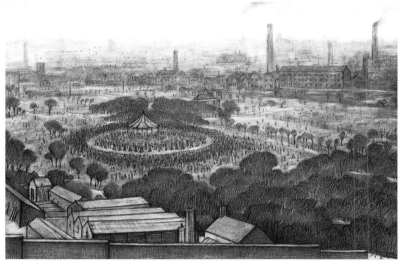

4

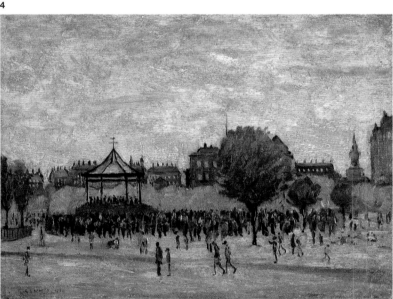

5

The Bandstand, Peel Park, Salford is one of a series of pictures that Lowry made of the area near the Salford College of Art, where he studied from 1915 to 1928. Lowry has the viewer standing high above the scene looking from a window of the Royal Technical College. The figures, though active and identifiable, are tiny, as they would be from this height. But in their masses, like iron filings around a magnet, they encircle the bandstand, giving it a grandeur which it does not have in its own right.

The factories and mills with their looming chimneys are situated on the other side of the River Irwell, and form the background which flows into the empty sky. The roofs of the greenhouses, situated in the foreground, make geometric patterns, and the wall at the bottom of the painting acts as a barrier for the viewer who stands behind it: an onlooker, like the artist himself.

6

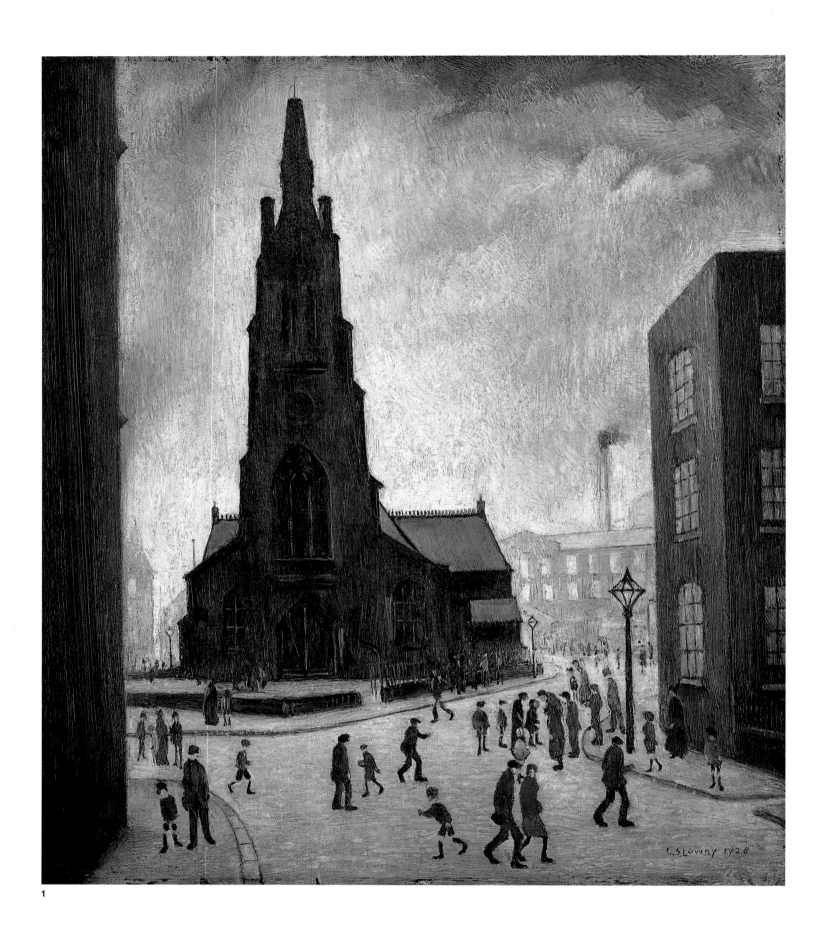

1

2

St Simon's Church, built of stone in 1849, stood in the northern part of Salford, surrounded by mills and engineering works, close to the River Irwell. It was a large church, built to hold about 1000 people. By 1923 the spire, which originally soared 150 feet, was partly taken down because of its dangerous state.

1 *A Street Scene – St Simon's Church* (1928), oil on board, 43.8 x 38.0 cm. Although Lowry had to be coaxed to see St Simon's, once he had, his artistic instinct took over. From the small sketch done on the back of an envelope at the site, Lowry was able to create a complete industrial scene.

2 Photograph: site of St Simon's Church, Salford. The site of the church is derelict and is surrounded by light industry. Most interesting is its position in relation to the river. Sometime between Lowry drawing this building in 1927 and the present, the course of the river changed. St Simon's was on the south side of the river, but its site is now on the north side.

3 *St Simon's Church (A Street Scene – St Simon's Church)* (1927), pencil on paper, 38.4 x 29.3 cm. Lowry developed this composition from a small incomplete sketch, expanding his notations to include a background mill, street furniture, and, of course, the people.

4 *St Simon's Church* (c 1927), pencil on paper, 10.2 x 10.8 cm. By the time Lowry's father drew his attention to St Simon's Church, Lowry was no longer doing major works out of doors. But his compulsion to record his environment led him to carry with him scraps of paper, old envelopes and other material on which he could draw.

5 Cover of the magazine of St Simon's Church, Salford, December 1908.

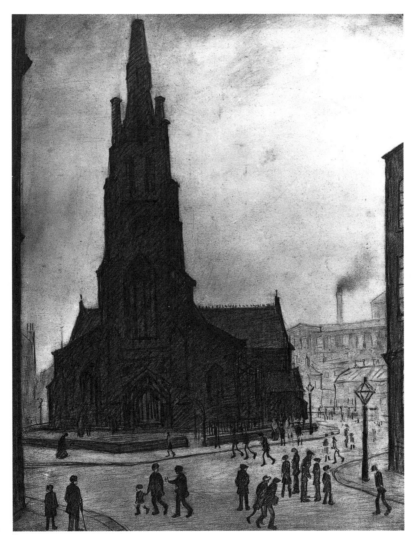

3

Three years later the church itself was closed. In 1927, Lowry's father suggested to him that he sketch the church. At first Lowry ignored the suggestion, but his father was insistent, saying: 'You'll really have to go and see the St Simon's Church, it's your cup of tea and it's going to come down very soon.'

Finally Lowry went. At the scene he produced a small sketch which he used as the basis for the later works. Returning in 1928, several months after his first visit, Lowry found the church had been demolished. The painting shows St Simon's with its truncated spire, black and brooding as it towers over its surroundings. It is, like most of Lowry's churches, an isolated lonely structure.

4

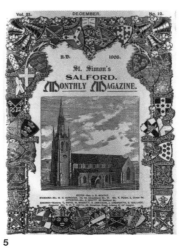

5

1

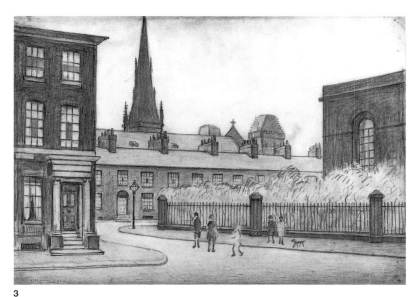

2

To the north of Chapel Street, set back from the road, stands a square piece of ground. In the centre of this space stands St Philip's Church. Built of stone in 1825, the Grecian-style building holds 1400 people.

1 *Church in Salford (St Philip's Church)* (1965), oil on canvas, 29.2 x 40.6 cm. Lowry left Salford in 1948. He returned to the area to visit Salford Art Gallery and to record buildings he had ignored when, as a student at the Salford College of Art, he had walked the surrounding streets. He knew St Philip's from the early years and, like so many of his images recalled at a much later time, he chose it because it suited the needs of his art.

2 Photograph: St Philip's Church, Salford. The church remains as it was in Lowry's time, but the activities of the surrounding buildings have changed: a car showroom stands at its right and offices at its left.

3 *By St Philip's Church* (1926), pencil on paper, 25.2 x 35.3 cm. The Georgian terraces stand in front of the spire of Salford Cathedral. The end wall of St Philip's Church is on the right. This view puts the church in the context of its neighbourhood and, unusually for Lowry's churches, it is only an incidental part of the scene.

4 Photograph: St Philip's Church, Salford.

3

According to Cornish's *Strangers Guide through Manchester and Salford* (1857): '… [it has] a circular portico over which is a tower bearing strong resemblance to a pepper box containing one bell and a clock with four dials.' The area around St Philip's has many Georgian buildings, including the County Courts, and was a place of special interest to Lowry. Unlike so many of the neighbourhoods he painted, it retains some of the character of its past, although individual buildings have been demolished.

St Philip's remains an active church. Although Cornish's *Guide* makes light of the church's architecture, Lowry has portrayed a heavy, threatening structure which, like his other churches, stares out of the picture at both the artist and the viewer. There is no comfort in its magnitude. Engaged in their own activities, the people are contained within the small space formed by the enclosing structures.

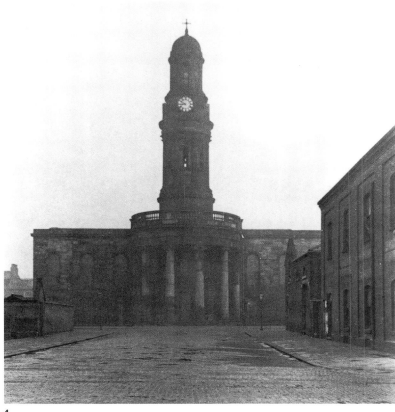

4

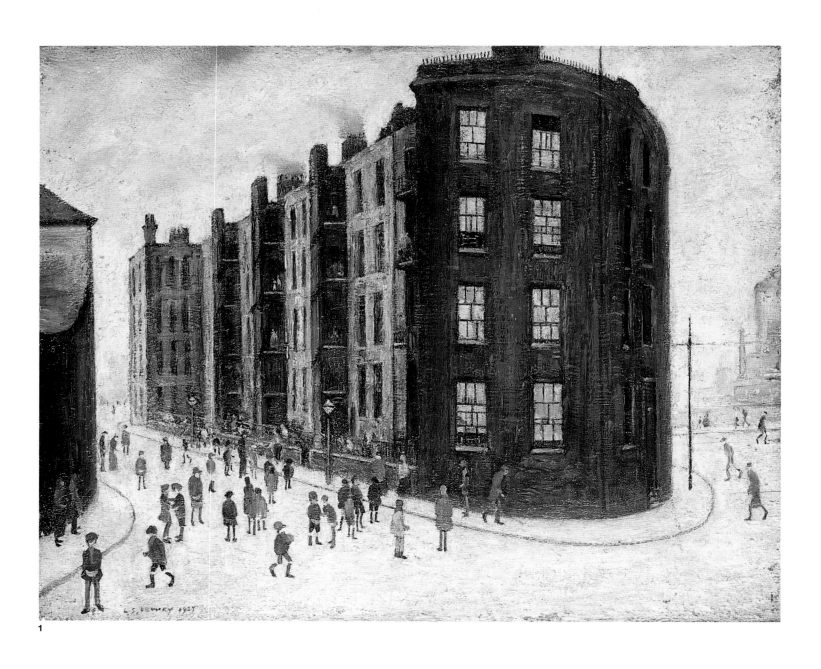

1

2

Standing opposite the Salford Royal Hospital on Oldfield Road, the Dwellings were built for artisans in 1893 under the auspices of the Yorkshire and Lancashire Railway Company. They were demolished around 1970.

1 *Dwellings, Ordsall Lane, Salford* (1927), oil on plywood, 43.0 x 53.5 cm. Lowry placed the Dwellings incorrectly on Ordsall Lane. Although he did not often do this, he could be lax in locating his scenes. This painting, as in most cases where Lowry repeated a subject, shows subtle variations from other representations of the image.

2 Photograph: site of Oldfield Road Dwellings, Salford. The Dwellings have been demolished and the site is derelict, but the streets, now deserted, are still as they were as is the sweep of the pavement.

3 *Oldfield Road Dwellings* (1929), pencil on paper, 41.2 x 43.8 cm. This detailed drawing of the Dwellings is as important as the painting. Lowry considered the two media of equal value.

4 *Study for Dwellings, Ordsall Lane, Salford* (1927), pencil on paper, 28.3 x 39.4 cm. The figures here have none of the detail evident in the painting and finished drawing. The buildings, however, though sketchily drawn, show all the elements of the structures.

5 Photograph: Oldfield Road Dwellings, Salford.

6 Photograph: Lowry at the back of Oldfield Road Dwellings, Salford, c 1957.

3

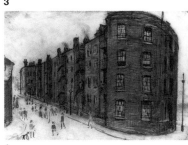

4

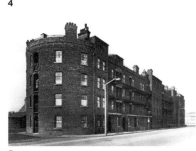

5

6

Lowry was enthralled with the Dwellings. In 1927, he said: 'I'd stand for hours on just this spot ... and scores of little kids who hadn't had a wash for weeks would come and stand round me. And there was a niff too.'

The structure consisted of two large, four-storey brick buildings, the first containing 12 'houses', the second, 48. The balcony of each house was protected by iron railings about four feet in height, and a high wall ran around the top of each building creating a roof yard. The two ends of the buildings were dissimilar, one end rounded, and the other, which faced the hospital, rectangular.

Although Lowry has created a topographical work in which the details of the buildings are carefully included, the reality of the site did not satisfy his artistic vision. To make it more acceptable, he changed the perspective.

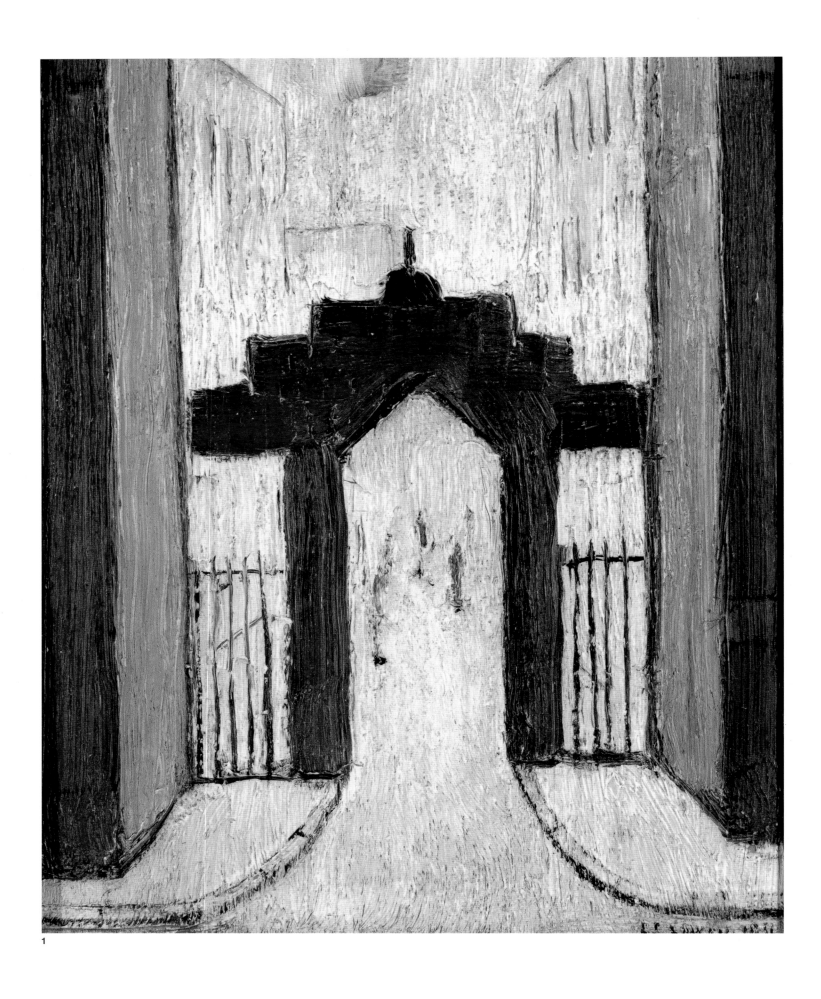

1

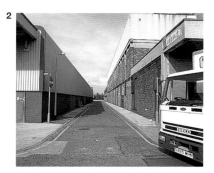

Salford Improved Industrial Dwellings, also known as the Greengate Industrial Dwellings, were built in 1870 to provide reasonable housing for some of those Salfordians who were living in appalling conditions.

1 *The Factory Gate* (1951), oil on panel, 19.0 x 16.5 cm. The gateway was an important part of Lowry's iconography. It often occurs in his industrial landscapes. However, by placing it on a white ground, with very little else to distract the viewer's attention, Lowry made it the focus of the painting – as he did the churches in his earlier works and the single figures in his later ones.

2 Photograph: site of Salford Improved Industrial Dwellings, Salford. These dwellings and the gateway are no longer there; industrial units have taken their place. The road configuration, however, is the same.

3 *Man Going to Work (Figure in a Gateway)* (1964), oil on canvas, 29.2 x 39.3 cm. Although obviously derived from the Improved Industrial Dwellings, the building has been modified once again and, like the painting opposite, shows the development of Lowry's art from detailed industrial scenes to the single uncomplicated image.

4 *The Gateway* (1931), pencil on paper, 22.0 x 21.0 cm. An early drawing of the Improved Industrial Dwellings which is not topographically correct. Not only has the shape of the gateway itself been changed, but, in keeping with Lowry's interests at this period, its setting has become more industrialised.

5 Photograph: Salford Improved Industrial Dwellings.

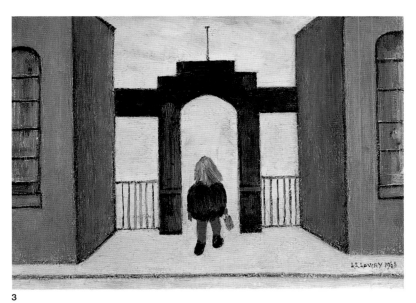

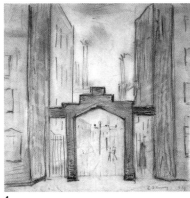

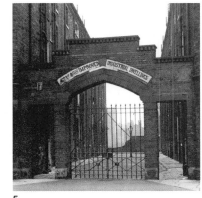

Traders such as stonemasons, blacksmiths, bookbinders and bricklayers were housed here. The Dwellings served the community until they were demolished in 1960. Constructed in two parallel blocks four storeys high, they contained 62 separate tenements and two shops which were joined by a gateway fitted with iron gates.

Lowry's interest focused on the gates, but he depicted them neither accurately nor consistently. They are fat or thin with tops rounded or straight; they may or may not be topped by a flagpole; even the shape of the archway has been changed, as has the number of stones on top of the gates themselves. Lowry found in this particular gateway an image that proved to be of great consequence, and he used it with subtle differences in a series of paintings and drawings which span almost four decades.

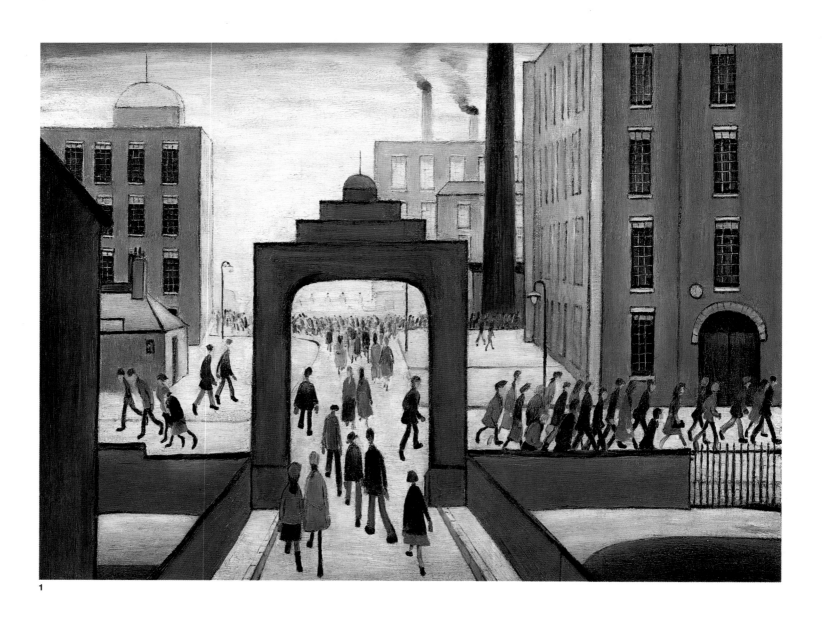

1

2

The gateway in *Early Morning* is similar to that of the Salford Improved Industrial Dwellings, and to those in the numerous paintings and drawings Lowry did of this site, but it is not exactly the same.

1 *Early Morning* (1954), oil on canvas, 45.5 x 51.0 cm. The gateway in this painting, with its side yards and fence, divides the work into two distinct parts. In the foreground, the gate and the empty yards with their surrounding walls, devoid of detail, lead to the future in Lowry's work; whereas through the gate, the work looks back to the industrial scene with its milling crowds, the factories with their chimneys spewing black smoke, and the mill with its ever-present dome.

2 Photograph: site of the Victoria Arch. The arch was demolished just after the mansion in Peel Park. There is no longer a view to the park from this position as the Maxwell Building of the University of Salford stands in the way.

3 *Sunday Afternoon* (1957), oil (primary support unknown), 114.3 x 152.4 cm. A panoramic view of Peel Park, with numerous modifications including a non-existent boating lake. Here the Victoria Arch has lost its onion-like ornaments, its shape has become that of the modified Improved Industrial Dwellings.

4 *Peel Park, Salford* (1944), oil on canvas, 38.0 x 76.0 cm. In this view of Peel Park, the Victoria Arch retains a semblance of its original form.

5 Photograph: Victoria Arch, leading from the Crescent into Peel Park, Salford.

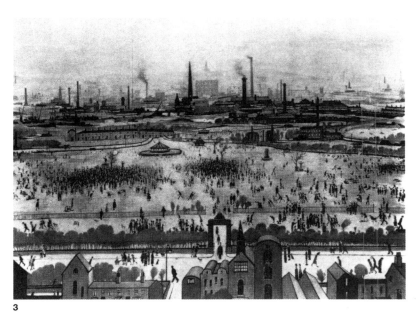

3

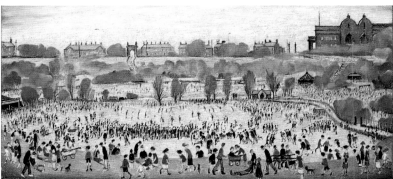

4

Although Lowry has retained the stepped lintel and the dome with the flagpole on top which appear in some of the paintings, but not on the building itself, the side openings have been removed and only the central arch remains. What is more unusual than the reduction in the number of openings in this painting is the placement of this archway in a non-industrial setting.

In *Sunday Afternoon*, Lowry seems to have combined the gateway of the Improved Industrial Dwellings with the Victoria Arch of Peel Park to form the entrance to the park, which itself has been transformed by Lowry's imagination. The River Irwell is filled with tankers, a boating lake appears from nowhere, and the industrial background is filled with buildings gleaned from Lowry's iconography. In the two paintings, industry and relaxation are opposites just like their titles, morning work contrasted with weekend afternoon pleasure, but both are entered through the same gateway.

5

'…Steps and things… I liked doing steps, steps in Ancoats… steps in Stockport… steps anywhere you like, simply because I like steps and the area which they were in was an industrial area. I did a lot, you see. I've never found it interesting to paint pure landscapes. I'm not interested in pure landscapes. I've done a few.'

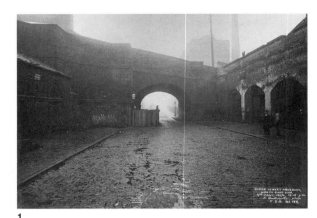

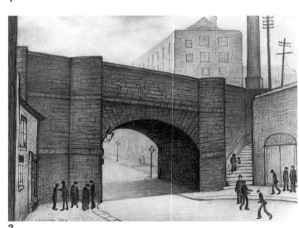

1 Photograph: The Viaduct, Store Street, Manchester.
2 *The Viaduct, Store Street, Manchester* (1929), pencil on paper, 27.2 x 37.6 cm.
3 Photograph: Lowry with his painting *Piccadilly, Manchester* (1957).

Interview with Hugh Maitland

Manchester

Lowry worked in Manchester at a property company from 1910 until he retired. Inspired by the areas around his home and college, his job as a rent collector provided him with the third place of importance to his art. Walking the streets of the city,

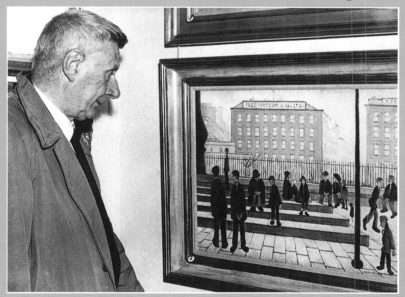

Lowry found canals, and their bridges, roadways and viaducts as well as the mills with their chimneys that seemed to fill the sky.

3

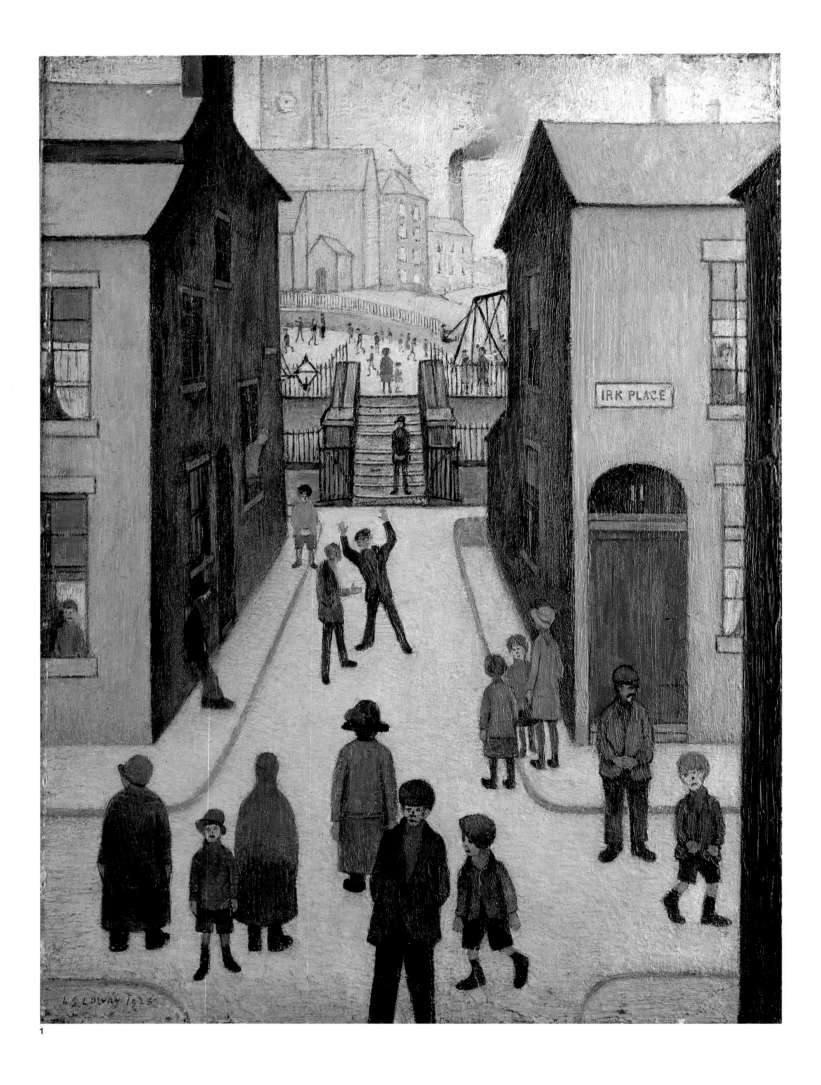

1

1 *The Steps, Irk Place* (1928), oil on canvas, 53.3 x 39.6 cm. As in many early paintings, the foreground figures in this work are static. Even those apparently walking appear as if caught up in a game of statues. In the background, however, the small figures seem imbued with life. Now there are few people in this industrialised area. St Michael's Church and the playground have been demolished. Only the flags and steps still exist in an oasis of green.

2 Photograph: The Steps, Irk Street, Manchester. The steps, which still lead to St Michael's Flags, and the Ragged School on their left, remain much as they were when Lowry drew them.

3 *View of a Town* (1936), oil on canvas, 40.6 x 50.8 cm. St Michael and All Angels stands as the main background image for this composite painting. The figures which hold the foreground are, like almost all of Lowry's people, isolated individuals, even if apparently together. The single figure looking at the scene has been placed directly in line with the church, thus leading the viewer to this monumental structure.

4 *Britain at Play* (1943), oil on canvas, 45.7 x 61 cm. This composite painting uses the sketch below to create the dominant background features. The church, set on a rise, looms over the landscape which has been formed from numerous images taken from Lowry's iconography: the bandstand in Peel Park, the terraced houses, and the gateway through which the crowds are filtered.

5 *Playground* (c 1927), pencil on paper, 9.0 x 14.0 cm. This sketch for St Michael and All Angels Church, and the playground on St Michael's Flags was drawn on a postcard; one of the many scraps of paper Lowry carried around with him.

6 *Lancashire Street Scene* (1929), pencil on paper, 39.5 x 27.0 cm. A different perspective on the same view as *The Steps, Irk Place*, and different figures.

2

The location of this painting is not Irk Place, as the title states, but Irk Street in the area known as Angel Meadow. The steps lead up to St Michael's Flags, which was formerly a burial ground for thousands of victims of diseases rife amongst the urban poor.

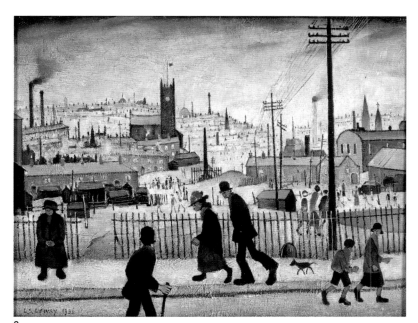

3

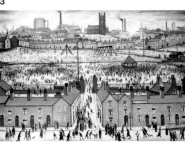

4

5

6

After the cemetery was closed in 1854, it became a playground around the now-demolished St Michael and All Angels Church, which was built in 1788 and seated 1000 people. The church was closed in 1929 and demolished around 1951. Once a wealthy district with Georgian houses and open vistas, it developed into an area confined by the industry around it. The meadows of the Irk Valley filled with factories, bad housing and railway viaducts. Two Ragged Schools were built nearby for the children of the poor.

By 1928, when Lowry was painting this scene, it was a place which encompassed every aspect of industrialisation with which he was obsessed. This obsession is evident in the numerous paintings and drawings which he produced over the next decades. He plucked the church and playground from their setting and set them down in the composite paintings which have no place but in the artist's imagination.

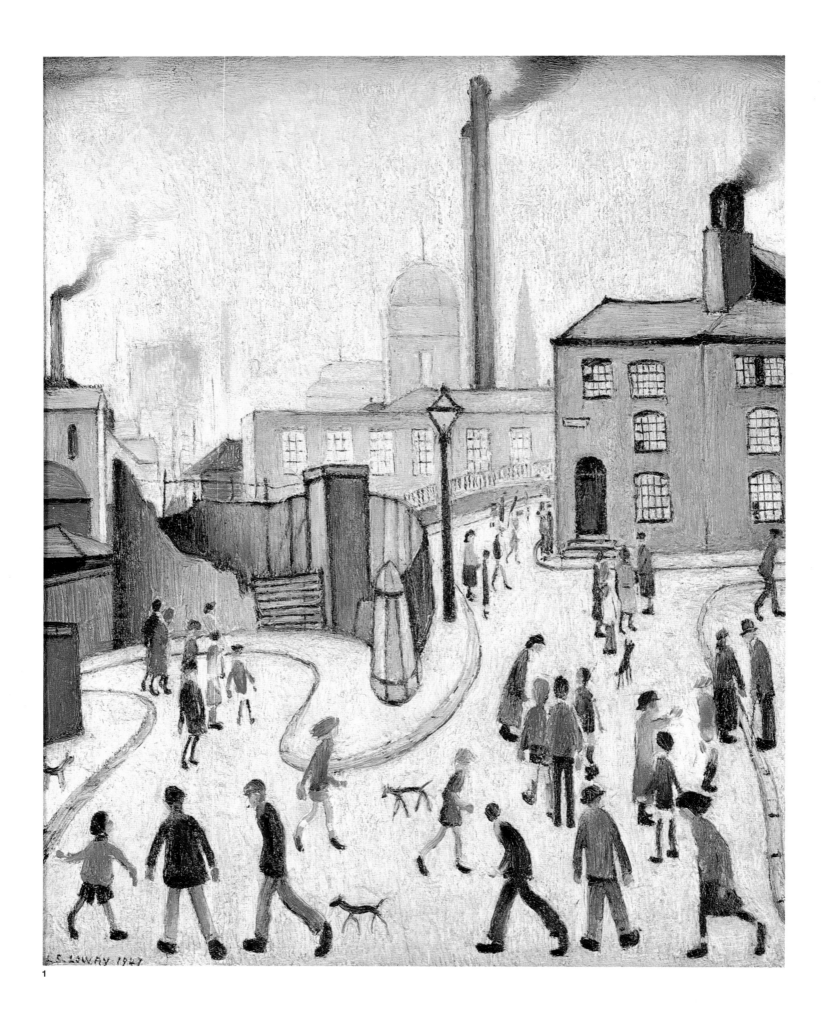

1

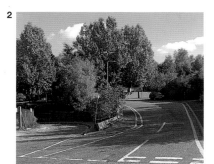

St Michael and All Angels, Angel Meadow is represented, like so many of Lowry's churches, as a monolithic structure, dwarfing the figures which stand before it. But Lowry's interest in the church goes beyond the building itself.

1 *Street Scene* (1947), oil on canvas, 51.2 x 41.2 cm. In the setting of St Michael and All Angels, Lowry has used his imagination to add three primary images of his industrial landscapes: the ubiquitous mill with the domed tower, the tall smoking chimneys and the church steeple.

2 Photograph: Site of St Michael and All Angels, Angel Meadow, Manchester. The gate posts which led to the church and the railings, now broken and rusted, are all that remain of the church.

3 *Street Scene* (1941), oil (primary support unknown), 53.0 x 43.0 cm. A longer view of the divided street showing major changes to the background: the mill has been removed, tall gate posts have been added, and the buildings to the left have changed. Even minor details, such as the crossbar acquired by the lamp-post seem to be significant. This painting, when compared with the one opposite, demonstrates how Lowry worked with each motif, putting it in or taking it out until it satisfied his composition.

4 Photograph: St Michael and All Angels Church, Angel Meadow, Manchester.

5 *Street Scene with Figures* (1944), pencil on paper, 53.3 x 40.6 cm. In this drawing of St Michael and All Angels, standing above the divided road, Lowry included none of the industrial images he incorporated into the later paintings of the same site. The church, looming over the landscape, is all that he considered necessary.

6 Eighteenth-century drawing of St Michael and All Angels Church, Angel Meadow, Manchester, artist unknown.

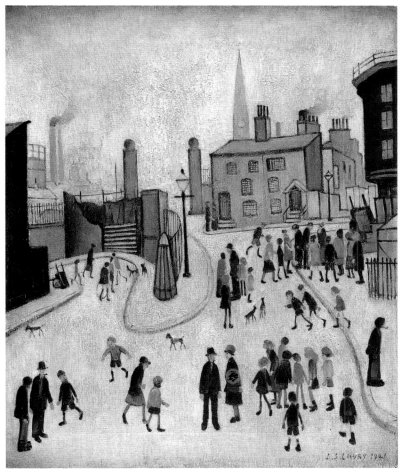

3

The road in front of the church splits in two, one going up the hill, the other down. It is this image, along with the house situated to the right of the church, that one finds repeated in Lowry's paintings over the years, even after the church itself had been demolished. But it is not the same scene. Most of the other elements have been changed: one has a mill and a chimney, one a spire of a church; gate and lamp posts appear or go missing as do various buildings. What inspired Lowry was only the basic structure of the site; around this, using the images taken from his iconography, he created his own vision.

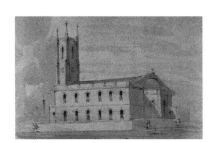

6

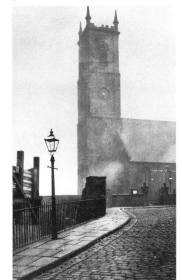

4

5

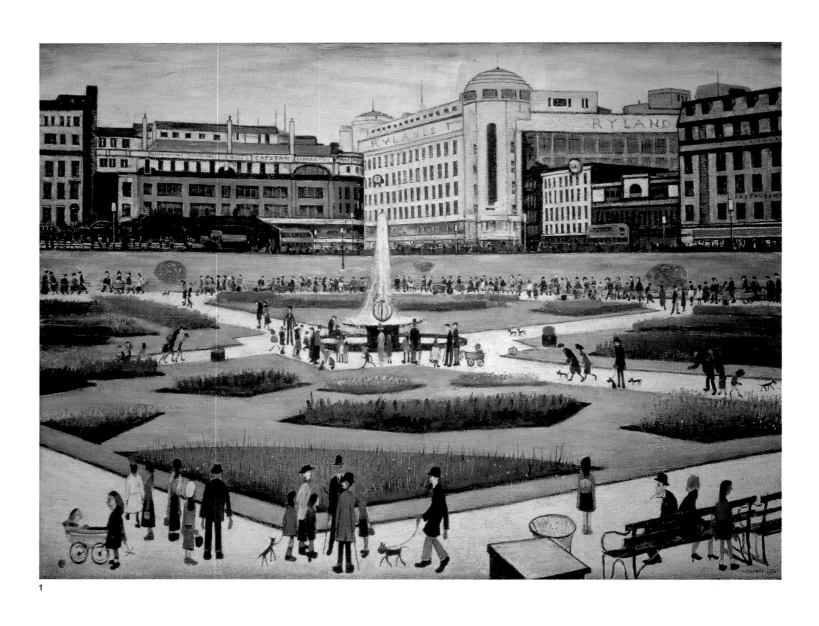

1

2

Piccadilly Gardens in the centre of Manchester was once the site of Manchester Royal Infirmary which came into being in 1755. Its demolition and relocation to its present position on Oxford Road began in 1908.

1 *Piccadilly Gardens* (1954), oil on canvas 76.2 x 101.6 cm. A topographical painting gives the artist little leeway for change. To be identifiable, the buildings have to be situated in their actual positions. Consequently, as in this work, there is not the variety of shapes and sizes which usually form the backdrop to Lowry's imaginative industrial scenes.

2 Photograph: Piccadilly Gardens, Manchester. The Gardens remain much the same as when Lowry walked their paths, but trees now obscure the view of the surrounding buildings that Lowry depicted.

3 *Piccadilly, Manchester* (c 1957), pencil on paper, size unknown. Seated on the steps outside Piccadilly Gardens are the individuals whose plight eventually drew the interest of Lowry away from the industrial landscapes and towards the single figures.

4 Photograph: pre-1908 postcard view of the scene, before the Manchester Royal Infirmary, on the right, was demolished.

5 Photograph: Piccadilly Gardens, Manchester, looking across to Rylands department store.

6 *Piccadilly* (1930), pencil on paper, 27.5 x 37.5 cm. This drawing shows the area to the right of the one above, and includes the tram line which passed around the Gardens. The tram was eventually removed, only to be reinstated decades later.

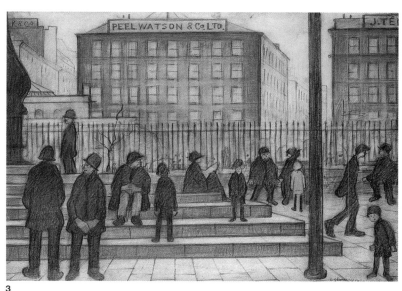

3

4

5

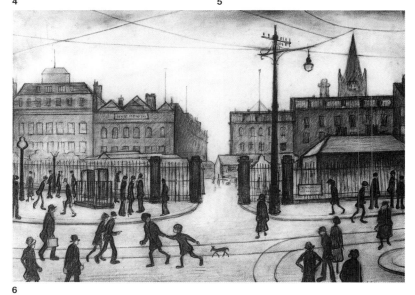

6

The Infirmary occupied a large site, for which a number of projects were proposed, an opera house among them. But there was also a desire to keep the space open. After much debate, the idea of an open space was accepted. However, it took many years to come to fruition.

Between 1908 and 1932 the site was divided. Huts for a temporary reference library stood in one part of the area and another section became a sunken garden. In 1930, Lowry was commissioned by the Curator of Manchester City Art Gallery to draw the site. Lowry complied, but his sketches were turned down. By 1935 the whole space had become Piccadilly Gardens.

Lowry often walked there. Sitting on the benches or walking the paths were the people who were to fill his paintings and drawings from the late 1940s onward. They were the poor, the homeless, the tired and the ill. He became as obsessed with them as he had been with the industrial scene. He would sit with them, in conversation or silence, sketching them and their sense of loneliness, the feeling he knew only too well.

Lowry filled this scene with people, alone and in groups, each engaged in their own activity.

1

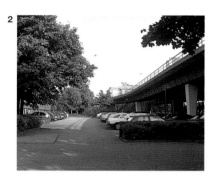

In 1940, St Augustine's Roman Catholic Church, which had been built in York Street near Oxford Road in 1908, was destroyed in an air raid. The site, a scene of dereliction, was not cleared until the 1960s when Manchester began a period of reconstruction.

1 *St Augustine's Church, Manchester* (1945), oil on canvas, 46 x 61.3 cm. The church stands as an empty shell amidst chaos. Did Lowry choose this subject because he empathised with it? It is a poetic statement from a man who on the death of his mother considered himself an empty shell, and who remarked to his friend, 'What is there left, what is there left?'

2 Photograph: site of St Augustine's Church, Manchester. The landscape is completely new. The site stands in the shadow of the Mancunian Way, near to Oxford Road.

3 Photograph: the ruin of St Augustine's Church, Manchester.

4 *Manchester Blitz (St Augustine's Church), Hulme* (1943), pen and black ink, and pencil on paper, 15.7 x 20.7 cm. As in so many of Lowry's sketches, only the basic image is noted; it is ultimately adapted for a drawing or painting, changed to suit the needs of the artist.

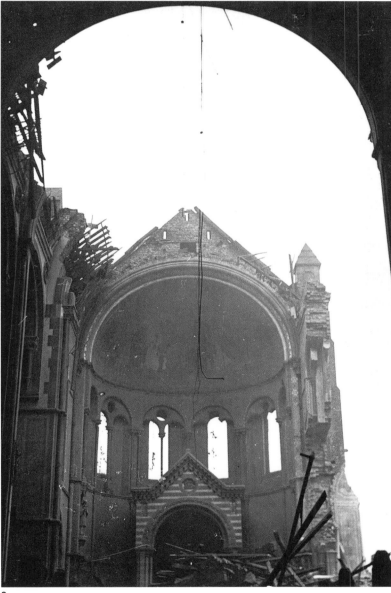

3

Although the bombing occurred while Lowry was a fire watcher in the centre of Manchester, he did not take note of this scene at the time; the sketch of the destruction, *Manchester Blitz, Hulme*, is dated 1943. In 1945, as an official war artist, he produced a painting from the sketch as part of his commission for the War Artists' Advisory Committee.

There was not much left of the church, but Lowry changed what there was. He removed the architectural element in front of the window at the back of the nave and in its place added a second layer of windows. Other details were also added and subtracted to suit his composition. Even in its destroyed state, Lowry has given the church the same brooding sense of awe and isolation that is found in the active churches which he depicted. Here, there is a reason for its separation from humanity; in the others there is not.

4

1

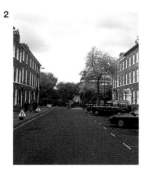

St John's Church was situated in Byrom Street, off Deansgate. It was built in 1769 as a memorial to John Byrom, the poet, originator of shorthand and the author of *Christians Awake;* it was demolished in 1931.

1 *St John's Church, Manchester* (1938), oil on canvas, 30.0 x 29.0 cm. The passing of the era of industrialisation began early in the 20th century, and Lowry was there to record it. St John's Church, like St Simon's in Salford, was demolished before the wholesale redevelopment of the 1950s and 1960s.
2 Photograph: site of St John's Church, Manchester. Commemorating this church is a plaque which stands on its site, in a small park, at the end of St John's Street.
3 Photograph: St John's Church, Manchester, viewed from Deansgate.
4 *St John's Church, Deansgate* (1920), pencil and white crayon on pale green paper, 18.0 x 12.8 cm. This sketch puts St John's Church in the context of an industrial river scene. Although situated in the background, it is the central image.
5 *St John's Church, Manchester* (1928), pencil on paper, 27.3 x 24.1cm. A close-up drawing, which presents the same view as the painting. The work is softly rendered, showing none of the violence evident in the way the paint was applied in the other picture.
6 *Sketch of St John's, Manchester* (c 1920), pencil on paper, 12.2 x 17.7 cm. This detail of the front of St John's shows the intricacy of the façade, something not visible in Lowry's painting and drawings of the church.
7 Photograph: St John Church, Manchester, viewed from Deansgate.

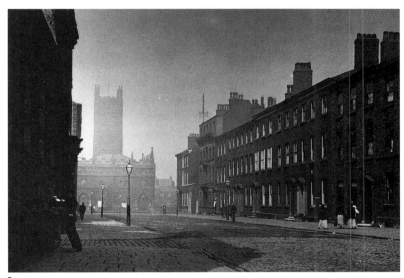

3

4

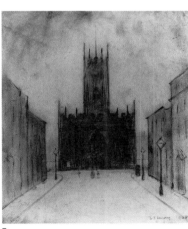

5

6

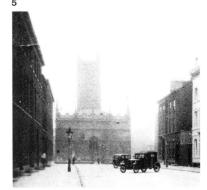

7

What Lowry has portrayed is a monolithic structure, black and foreboding, presenting its façade in all its magnificence to the viewer, who is caught in its spell. This painting, dated 1938, is not like the paintings of the empty, derelict sites and haunting portraits which permeate this period of Lowry's work. Rather, it foreshadows his later works, when the single figure against the white background becomes the symbol of his vision. But the feelings of pain caused by his mother's illness are apparent in the paint itself, which has been applied in thick impasto with short violent strokes.

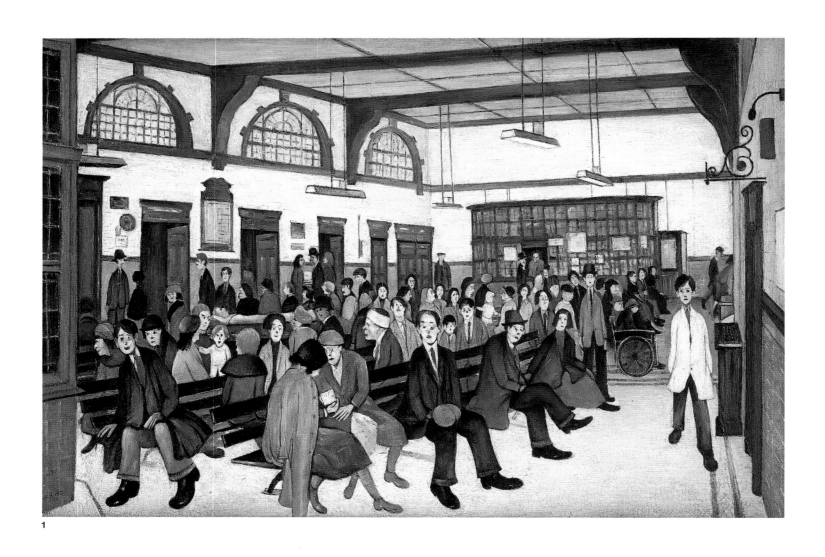

1

This institution for the poor originally opened in Great Ancoats Street in 1828 as the Ardwick and Ancoats Dispensary; an enlarged Ancoats Hospital was opened in Mill Street, Ancoats in 1874.

1 *Ancoats Hospital Outpatients' Hall* (1952), oil on canvas. 59.3 x 90.0 cm. For this painting, Lowry used a photograph much as he used sketches for other works. He noted the important features, but changed what he felt was necessary for the creation of a work of art and not just a copy of the scene.
2 Photograph: site of Outpatients' Hall, Ancoats Hospital, Manchester. This part of Ancoats Hospital was demolished, but a new building has risen in its place which houses the x-ray department.
3 *Outpatients' Hall, Ancoats Hospital* (date unknown), black chalk, pencil and watercolour on paper, 27.2 x 38.1 cm. In this sketch Lowry has removed all detail; only the postures and positions of the figures remain.
4 Photograph: waiting room of the Outpatients' Hall, Ancoats Hospital.

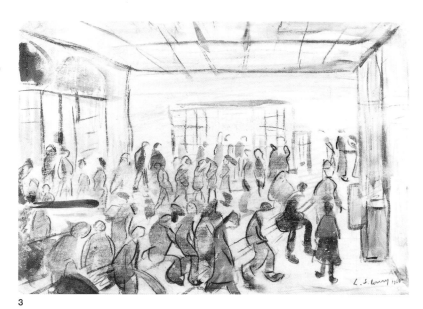

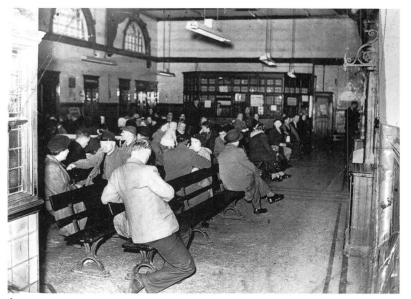

The painting, commissioned by the Medical Committee of Ancoats Hospital as a memorial to the late Peter McEvedy, a talented and creative surgeon, is unusual when one looks at Lowry's work overall. Firstly, the view of the hospital that he has represented is inside the building, not the usual exterior view, and secondly, where he usually worked from sketches and his own imagination, a photograph, perhaps presented by the commissioning body, was an important aid to the composition.

By the early 1950s, Lowry was moving away from depicting industrial scenes towards a more detailed view of the people who inhabited them. The reception area of the hospital provided him with the kind of people he wanted to portray: the poor and the injured. Although he tended to represent those who were hurt socially and emotionally, the 'down and outs', Lowry also saw a certain fragility in the individuals waiting here for treatment.

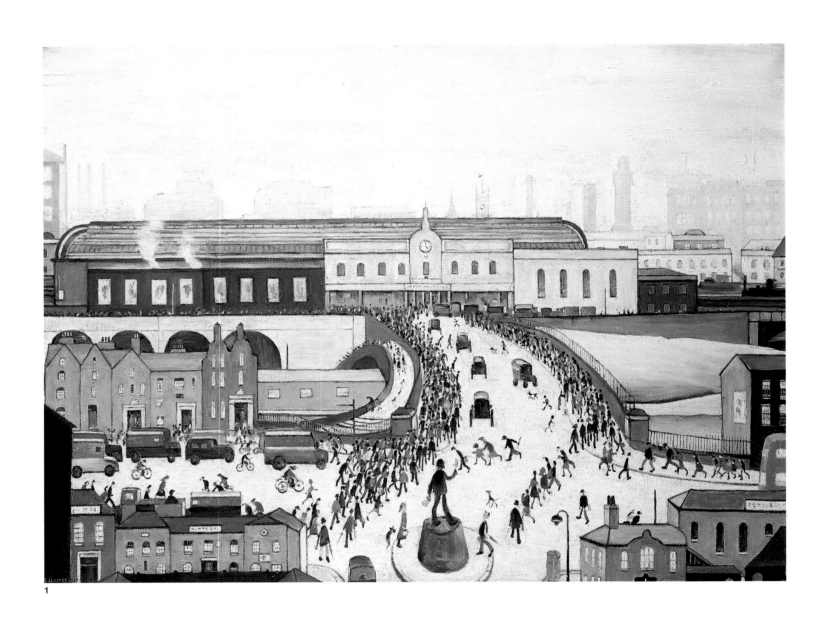

1

Part of the London and North Western Railway, Exchange Station was opened in 1884. After many years, its platform was joined with that of Victoria Station, about a quarter of a mile away, to form the longest rail platform in the United Kindgom.

1 *Station Approach* (1960), oil on canvas, 75.0 x 100.0 cm. How similar this painting is to Lowry's mill scenes. The figures move as a unit towards the station, as if they must arrive at the same time to begin an identical journey. The motor vehicles too, a feature which Lowry seemed averse to including in most of his work, are all moving in one direction.
2 Photograph: site of Exchange Station, Manchester. The station is gone and a car park stands in its stead. However, the railway arches and the approach road, which leads to the car park, are identifiable.
3 Photograph: Exchange Station, Manchester with the statue of Oliver Cromwell.
4 *Station Approach* (1962), oil on board, 41.0 x 50.8 cm. Presented by Lowry to the Royal Academy on his election as a member, this painting has little of the interest of the painting opposite. The figures do not have individuality, the background is constructed of amorphous shapes, and the buildings do not have the variety of shapes and sizes.
5 Photograph: Exchange Station, Manchester viewed from Deansgate.

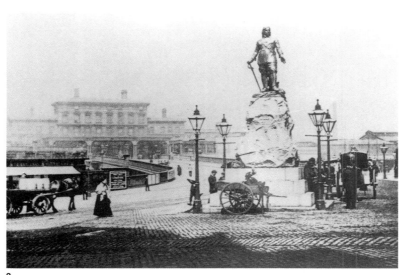

3

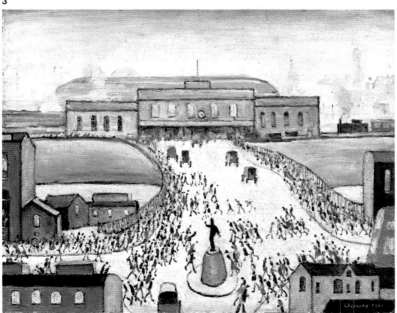

The approach to the station from Victoria Street was by a wide bridge over the River Irwell. A statue of Oliver Cromwell, presented to Manchester in 1875, stood at the junction of the approach road and Victoria Street. In 1968 it was moved to Wythenshaw Park. The station, which was bombed during the Second World War, closed in 1969.

Lowry was inventive with both the façade of the station and with its environment. The buildings standing in front are similar to those situated around the corner in Greengate, and the viaduct has been relocated. He added a pedestrian bridge below the main approach road, and a clock tower to the front of the building. In the background he put the tower of Strangeways Prison, a landmark for the area, thereby identifying the station.

4

5

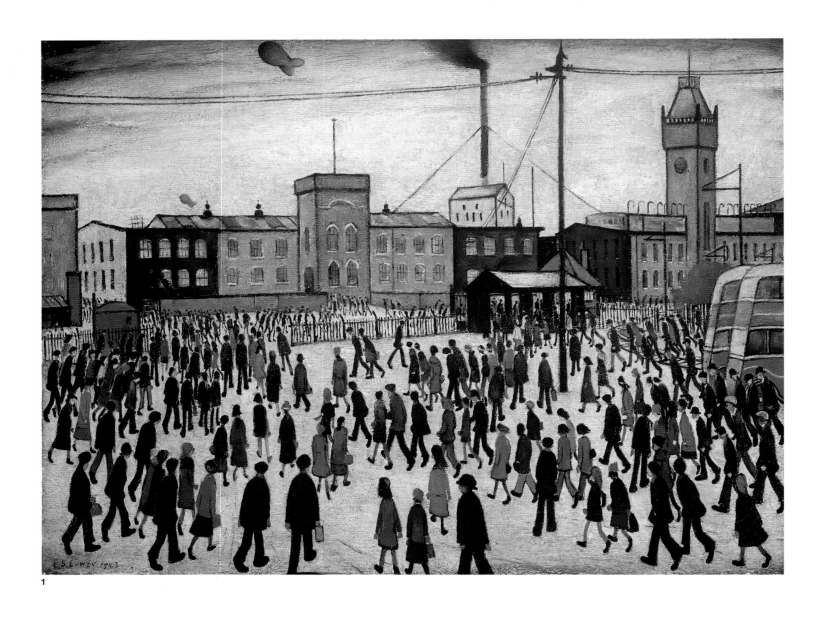

1

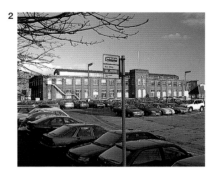

In 1942 Lowry was appointed a war artist. When asked by the War Artists' Advisory Committee for a view of factory life, Lowry produced *Going to Work*. It is a typical industrial landscape, composed of large crowds and factory buildings; only the barrage balloons make reference to the war.

1 *Going to Work* (1943), oil on canvas, 45.8 x 61 cm. Many people working at Mather and Platt either travelled by train to nearby Park Station or were delivered by bus. The scene is the start of the day, with hundreds of people moving towards their place of work. It is a situation which Lowry would have observed time and again in Pendlebury, and which he translated onto canvas for over forty years.

2 Photograph: Site of Mather and Platt, Park Works, Manchester. The main tower has been demolished but the building on the left remains.

3 *Industrial Landscape* (1955), oil on canvas, 114.5 x 152.0 cm. In this composite industrial panorama, the architectural features completely dwarf the figures, whose very existence seems insignificant, and whose inclusion seems unimportant both to the scene and to the artist himself.

4 Cover of the Mather and Platt magazine showing the tower.

5 Photograph: Tower of Mather and Platt's Park Works.

6 *Going to Work* (1944), pencil on paper, 27.3 x 36.5 cm. Lowry has put considerable detail into this drawing. Unlike many of his other sketches, where only the buildings are noted, Lowry has here identified the people in the crowd and transferred them with their background to the painting. Dated after the painting, it is likely that the drawing was misdated when the date was added later.

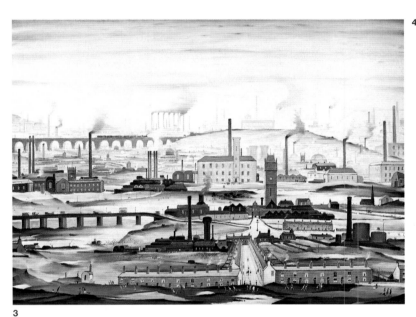

3

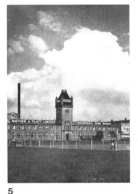

5

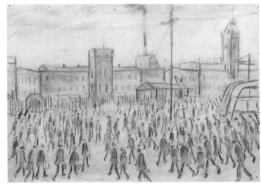

6

4

The scene, based on the tower block of the engineering firm of Mather and Platt Ltd, is situated about two miles north-east of the centre of Manchester. Originally based in Salford but unable to expand, Mather and Platt moved at the turn of the century to a new site at Park, Manchester.

The tower, demolished in 1998, had a wooden substructure and brick facing, and was used as the offices of the firm which produced high-speed engines, winding gear, pumps and much more. Lowry was obviously impressed with the tower, as he also took it out of context and relocated it in his large *Industrial Landscape* (1955).

Here the building is the focus of a detailed panorama which features all manner of architectural images, including those which Lowry had accumulated over the years.

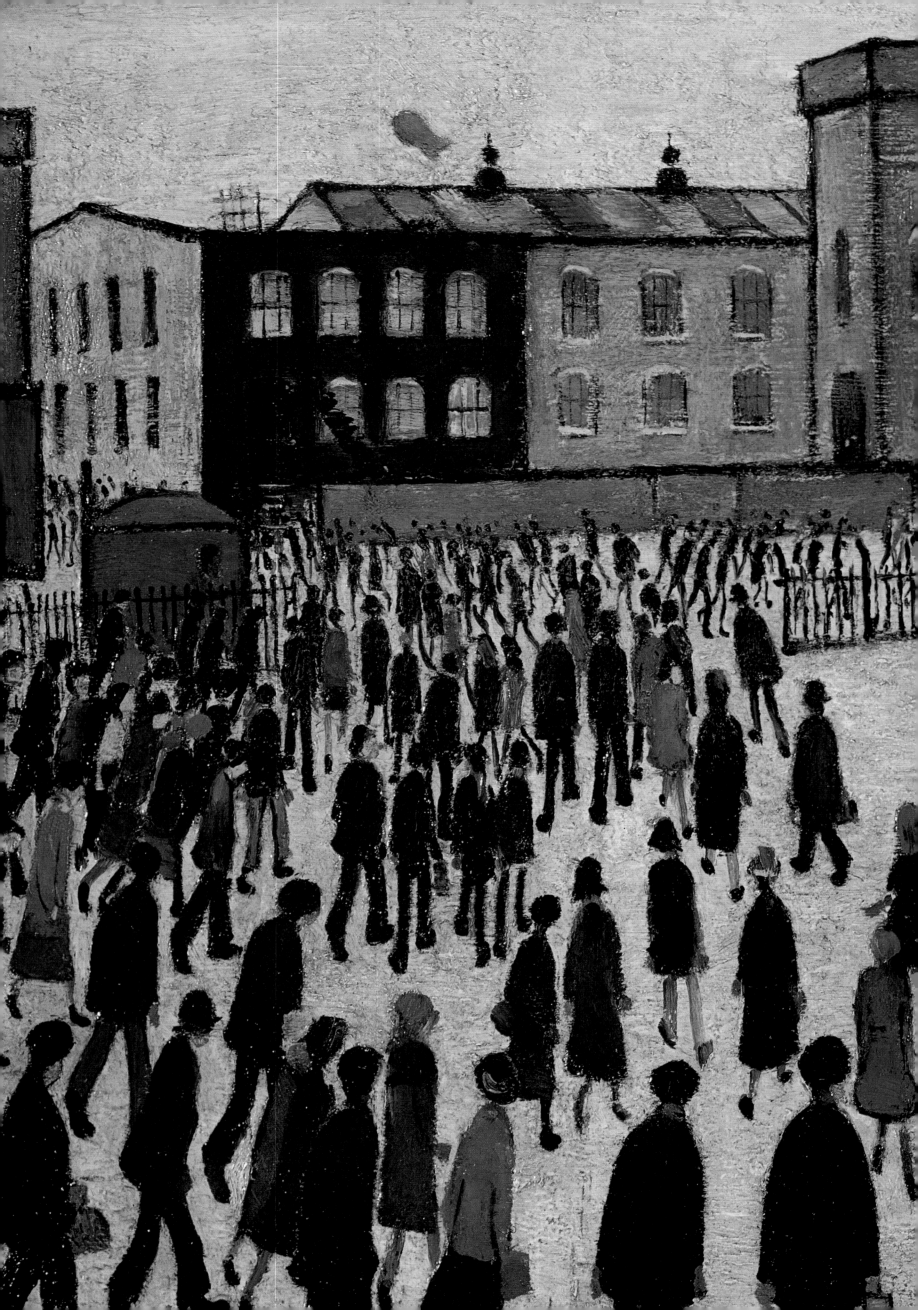

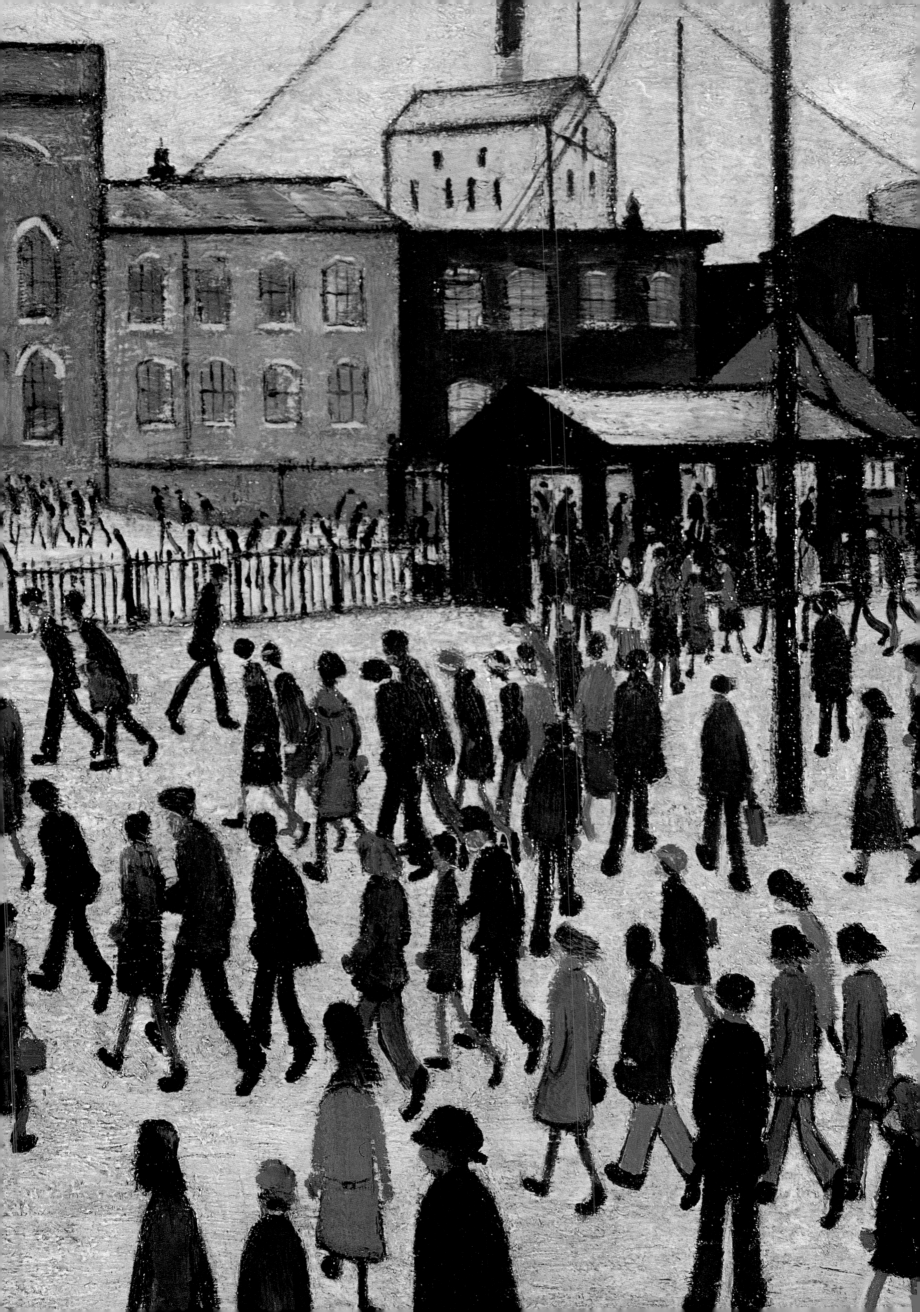

'I came to Mottram because all my associations with the past had gone. There was sadness in Station Road, Pendlebury, and I knew I had to get away somewhere. I came to Mottram because a friend said it was as good as any-where else. I've no sense at all, you know. I've no desire to live anywhere but this friend said why not come and live in Mottram. I have unfortunately no ties at all and I'm free to go anywhere I like. I've been intending to move all the time. My friends are very much amused, but they say I'll never move and I suppose they're right. It's far easier to keep this house as a storage place for all my jumble, a room for a studio and a bed for the night.'

1 Photograph: the hall at Lowry's house, The Elms, Stalybridge Road, Mottram-in-Longdendale.
2 *The Hat Rack* (1966), pencil on paper, 24.0 x 18.0 cm.
3 Lowry at work in The Elms, where he lived from 1948 until his death in 1976.

Nova Magazine

Mottram-in-Longdendale and the East

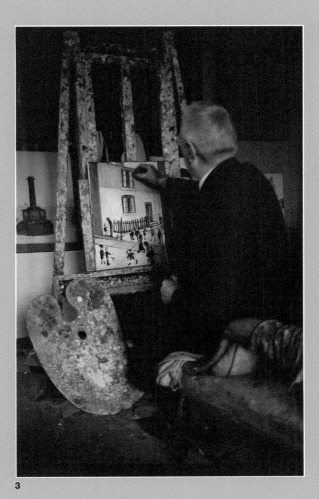

3

In 1948 Lowry left Pendlebury and after a six month stay in Swinton, moved to Mottram-in-Longdendale in the county of Cheshire. But even before that relocation he was familiar with some of the communities which border the Pennines. Part rural, part industrial, Droylsden, Ashton-under-Lyne, Oldham and Middleton provided subjects for a number of significant paintings and drawings.

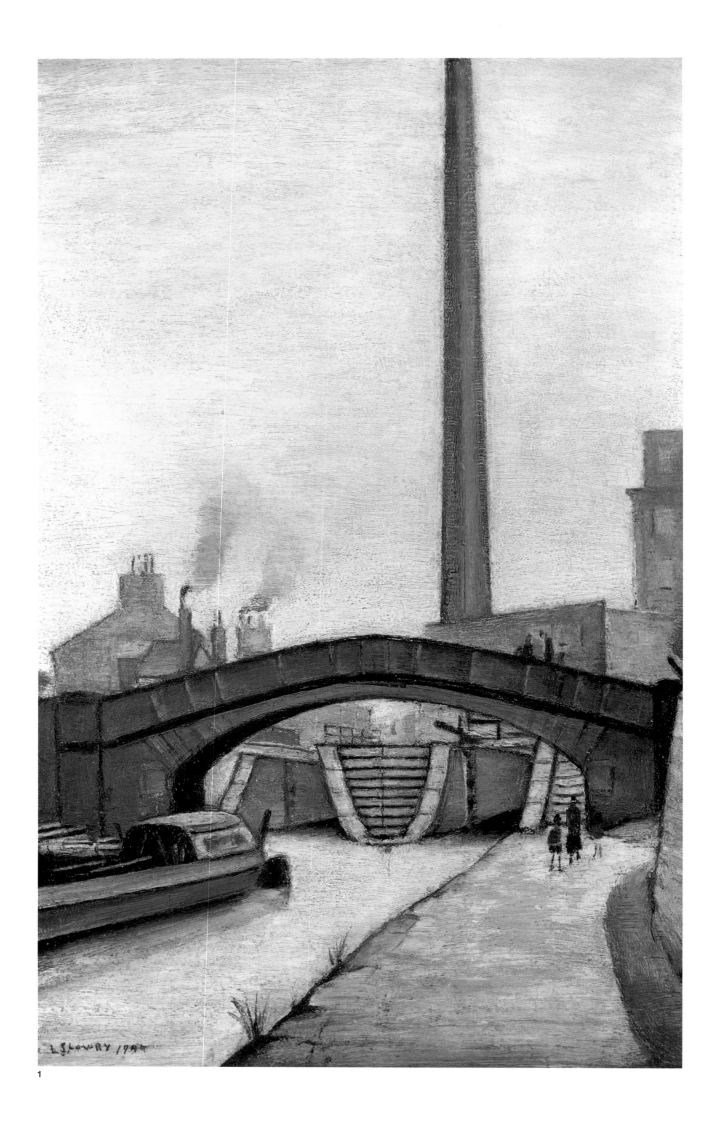

1

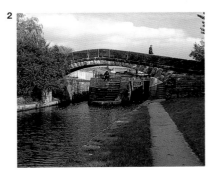

2

In 1797, the Ashton Canal, one of the canals of the north-west network, was completed. Almost seven miles long, it joined Manchester with Ashton-under-Lyne. It was built to create a new trade route from Manchester to the textile mills of Ashton and to provide transport to and from the coalfields of Oldham.

1 *The Canal Bridge* (1944), oil on board, 47.5 x 30.0 cm. Fairfield has an area similar to that near St Philip's Church in Salford. This was the Moravian settlement, hidden from view but within metres of the canal, consisting of Georgian terraces on cobbled streets, a Sunday school and a cemetery. Walking along the canal, Lowry may have been unaware of this community, or perhaps he no longer had an interest in Georgian buildings. Bridges and chimneys, however, portrayed either separately or together, were an integral part of Lowry's iconography from his earliest industrial period onwards.
2 Photograph: Top Lock, Fairfield. The lock and the bridge are still in use but, like other canals, for leisure rather than industry. The chimney, a sign of the industrial past, has gone. The local residents make use of the towpath and foot bridge.
3 Photograph: the Canal Bridge, Top Lock, Fairfield.

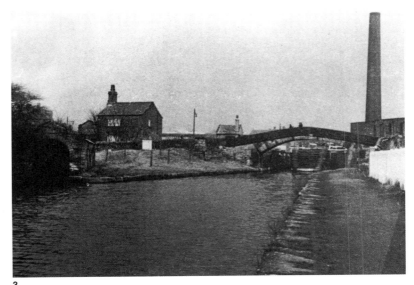

3

Because of the large amount of traffic on the canal, Top Lock at Fairfield was built as a double canal. A stone boathouse below held the packet boat in the days of passenger travel.

Lowry, who often drew the area around the Ancoats end of the canal, would almost certainly have walked to the Fairfield locks. The hump-back bridge, typical for its purpose, allowed horse-drawn barges laden with goods to pass under it and pedestrians to pass over it. Through the bridge, one sees the overflow of the two canal locks and the chimney of the neighbouring factory.

'Paint the place you know' was Lowry's advice to young artists. He knew how important it was to empathise with his environment, to be obsessed by it. It was the only way to give expression to his artistic vision. Although he represented this scene fairly accurately, he changed whatever he felt was necessary to create the image he wanted.

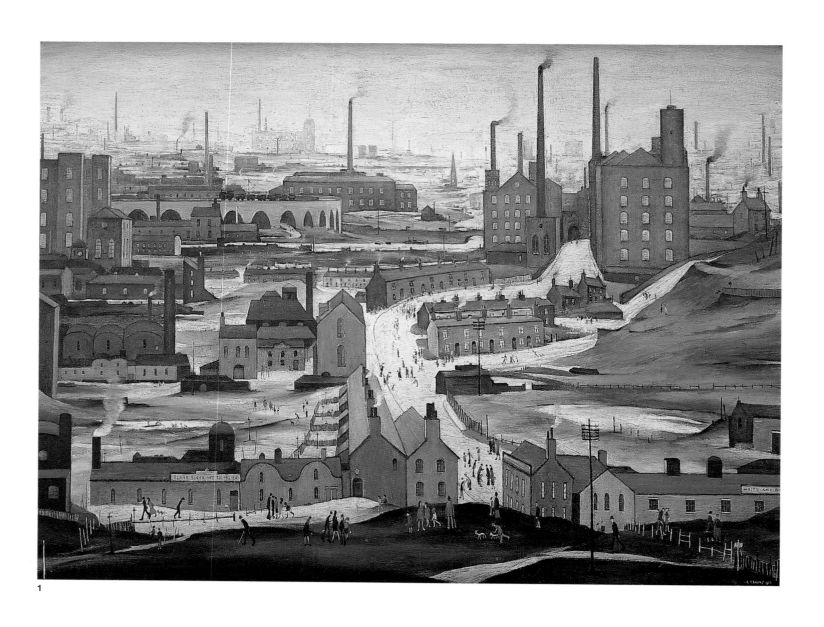

1

Lowry identified the location of this industrial landscape as Ashton-under-Lyne, a Lancashire town about seven miles to the east of the city of Manchester and about five miles to the west of his home in Mottram-in-Longdendale.

1 *Industrial Landscape, Ashton-under-Lyne* (1952), oil on canvas, 115.0 x 152.5 cm. This panorama of Ashton-under-Lyne is a classic example of a composite painting. The buildings are all there, but not in their actual places. Lowry's vision was not the static landscape he saw before him, but an altered view. He included a viaduct from here, a mill from there and a church from somewhere else; he changed perspective, removed a chimney, rotated a building whilst moving it from one street to another. The result was both Ashton and not Ashton.

2-3 Photographs: St Stephen's Church, Guide Bridge, and Cavendish Mill, Ashton-under-Lyne. Cleaned and now used as an apartment building, the mill stands across a busy road from a supermarket.

4 Photograph: Wharf Mill, Lower Wharf Street, Ashton-under-Lyne.

5 Photograph: Cavendish Mill is seen in the background with its chimney.

6 Photograph: St Stephen's Church, Guide Bridge.

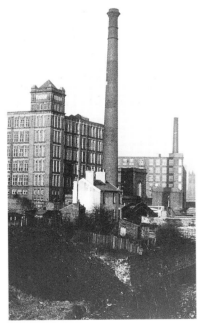

4

Ashton is a fairly large industrial town whose skyline was filled with mills and their smoking chimneys; churches abound, and two railway viaducts dominated the valley of the River Tame. The view of Ashton is from the former Park Parade Station, which looked out across the valley away from the town centre. To the right is Wharf Street Mill, now demolished, which stood on Lower Wharf Street. Immediately to its left, but set into the background, is St Stephen's Church, Guide Bridge, a town bordering Ashton to the south-west. At the left edge, in the background, is a section of Cavendish Mill; on its right is a viaduct in front of which passes the River Tame.

This all seems straightforward, but it is not the reality of the scene. From Lowry's vantage point, neither of the two viaducts of Ashton would be found in the position depicted. The chimney, so distinctive on Cavendish Mill, has been removed and the view of the mill is that which one would see from the opposite direction. These and other changes to the landscape of Ashton-under-Lyne have been made to produce an imaginary industrial town. But not quite. So many of Lowry's industrial landscapes have structures or features which can be located in a real town, but not all and not from the same location.

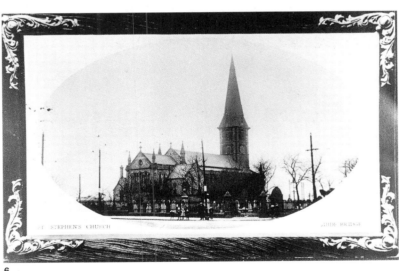

5

6

85

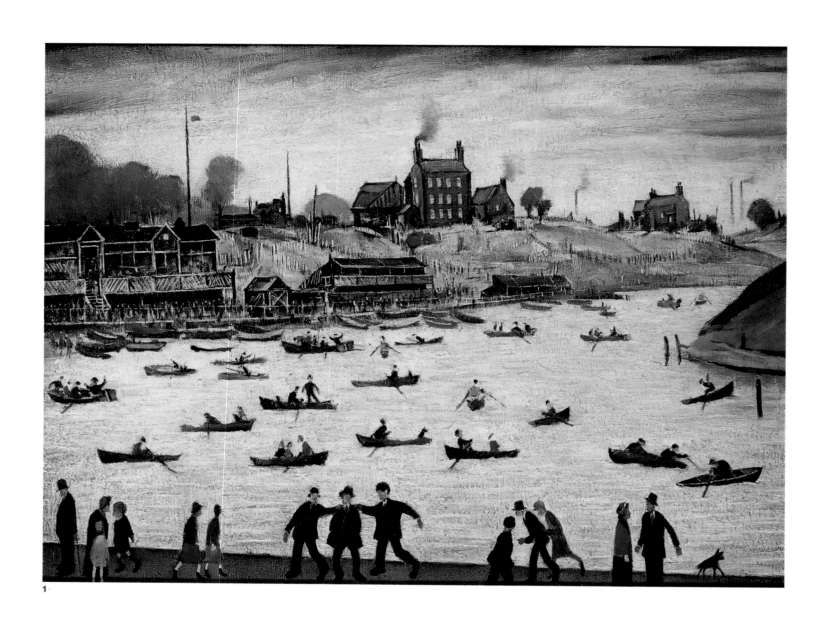

1

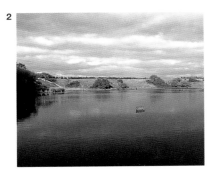

2

Opened in 1797 to supply water to the Fairbottom Canal, Crime Lake was situated in what had been the Crime Estate. Its name, as found in Cryme Bank, was known as long ago as 1599, but one can only speculate on the reason for it.

1 *Crime Lake* (1942), oil on board, 43.7 x 59.1 cm. At first the eye is drawn to the numerous rowing boats on the lake; further examination reveals that many of the figures in the boats are involved in little dramas, for which the viewer must supply the details.

2 Photograph: Crime Lake, Droylsden. A site for local anglers, the lake is no longer used for boating. The boathouses have been demolished.

3 Photograph: boathouse, Crime Lake, Droylsden.

4 Photograph: boathouse, Crime Lake, Droylsden.

5 *The Arrest* (1927), oil on canvas, 53,3 x 43.2 cm. Lowry had an affection for this image, and placed it in several of his paintings.

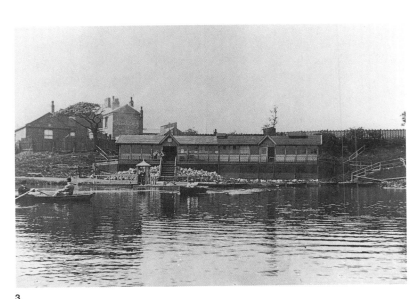

3

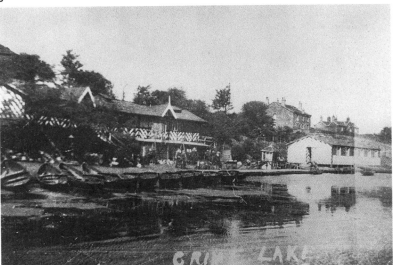

4

The lake is close to Daisy Nook. The two sites, together, provide residents and visitors alike with a large recreational area. The view, of people in rowing boats with others lining the bank, is reminiscent of the painting *River Scene*, but in this case there is no doubt about the circumstances.

Lowry, however, has used this pleasant activity as a backdrop for a more unpleasant one, suggested by the name of the lake. The focus of the painting is in the centre foreground where two men stand with their hands on the shoulders of a third. This scene is like the one that takes place in Police Street in *The Arrest*. Lowry was always interested in the unusual. The visual jokes he created, by associating the place names with events, show his sense of humour.

5

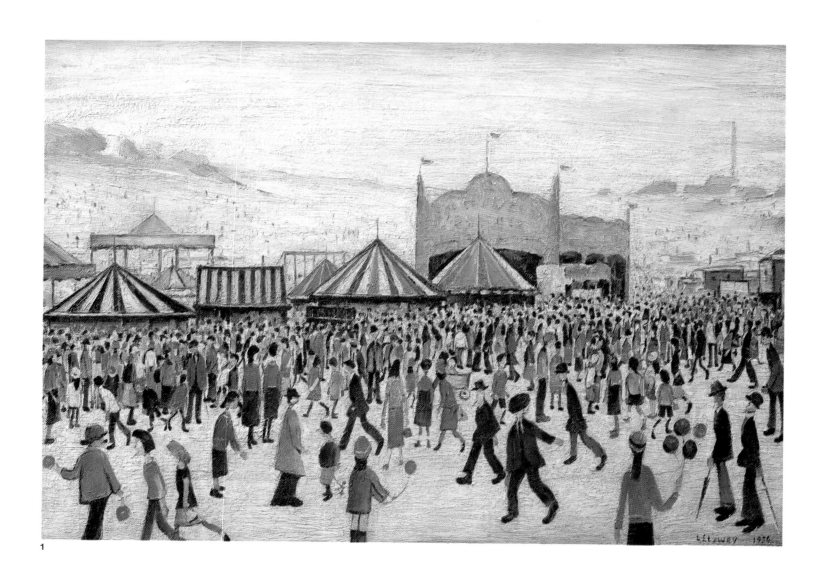

1

2

In 1855, Ben Brierly wrote a 'A Day Out' in *Daisy Nook Sketches*. The location was based on the riverside village of Waterhouses in the Parish of Ashton-under-Lyne. People from the area and beyond were drawn to the rural spot on the River Medlock which became known as Daisy Nook.

1 *Fair Ground at Daisy Nook* (1956), oil (primary support unknown), 35.5 x 50.8 cm. One of numerous versions of this event, it shows Silcocks Fair as the backdrop for the crowd; the foreground figures, which stand apart, are placed in small groups, each involved in its own activity.
2 Photograph: Daisy Nook, Droylsden. The site of the fair has become smaller over the years although it still takes place on Good Friday and is still run by the Silcock family.
3 Photograph: factory chimney overlooking Daisy Nook.
4 *Lancashire Fair, Good Friday, Daisy Nook* (1946), oil on canvas, 72.5 x 91.5 cm. In this version of the fair, the individuals are much more spread out, Lowry using the space between them both to join them together and isolate them.
5 Photograph: the Fair on Good Friday, Daisy Nook.

There were only two statutory holidays for the mill workers, Good Friday and Christmas Day, and because of the influx of people into Daisy Nook, an annual festival was held on Good Friday. Good Friday at Daisy Nook was an ideal scene for Lowry. Run by the Silcock family, it provided a great variety of entertainment and refreshment. The open fields filled with pleasure-seeking people and Lowry was there to record them. Although there is only a hint of industry, the chimney far in the background, Lowry found the scene sufficiently important to paint many versions of the same event.

As with his industrial paintings, the crowd fills the foreground and the activities, both planned and unplanned, seem infinite. Everywhere one looks, something is going on. The tents and caravans

form a thin line between the foreground and background and act as a boundary to the scene. There are few rural scenes which Lowry could depict as he did his industrial ones, other than the great fairs. In this case, there is no doubt that Lowry was accurate in his rendition, particularly of that lonely chimney and building standing on the hill.

When out bicycling near Daisy Nook, an acquaintance of Mr Lowry saw the artist and asked him what he was doing. Lowry had explained that 'he was doing a painting and had forgotten the outline of the background. He took out of his pocket an envelope on the back of which he had drawn the pump house and tall chimney...'

3

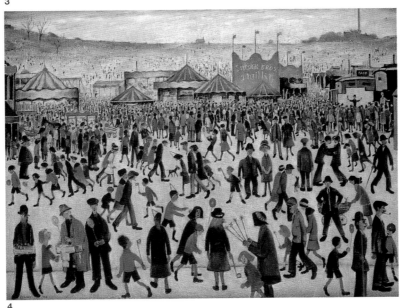

4

5

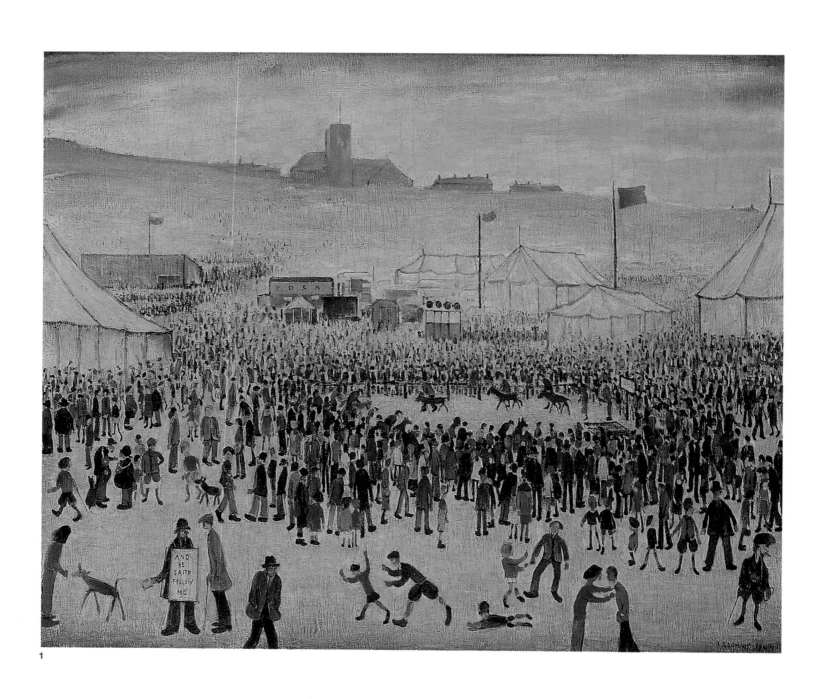

1

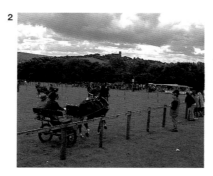

In 1948 Lowry left Pendlebury, which had been the original inspiration for his work, and moved to the Cheshire village of Mottram-in-Longdendale. He lived in a stone cottage with a lean-to kitchen on the Stalybridge Road not far from the imposing 15th-century St Michael and All Angels Church.

1 *Agricultural Fair, Mottram-in-Longdendale* (1949), oil on canvas, 64.1 x 77.5 cm. Mottram Church, situated on a hillside overlooking the fair, has been given the significance which the church, as an iconographic image, often had in Lowry's industrial paintings. The figures too, are placed in little vignettes, a characteristic of almost all of Lowry's crowd scenes.
2 Photograph: The Agricultural Fair still takes place in August, but at a location different from that painted by Lowry. The original site is now a Tameside Leisure Centre.
3 Photograph: Agricultural Fair, Mottram-in-Longdendale.
4 Photograph: Mottram Church overlooking the site of the Agricultural Fair ground.
5 Photograph: Mottram Church from across the valley.

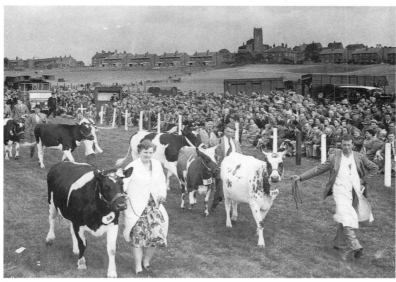

Mottram was certainly not an industrial area and Lowry made great claims to dislike both his house and the place itself; but it did have things to interest him. Foremost was the Agricultural Fair which took place in the valley below the church in August of each year.

'They're nice folk,' he said, 'I've nothing against them. It's the place. Never could take to it. I can't explain it. I've often wondered. Sat down for hours and tried to ponder it. It does nothing for me. I know there's plenty to paint here, but I haven't the slightest desire to work locally. I've done one painting of the local agricultural show. Was commissioned to paint the parish church, but had to give it up. I couldn't do it.'

It is evident that Lowry's interest in the life of Mottram lay only in the relationship between it and his earlier work. Here the crowds, which filled his industrial paintings, are gathered around the parade of farm animals.

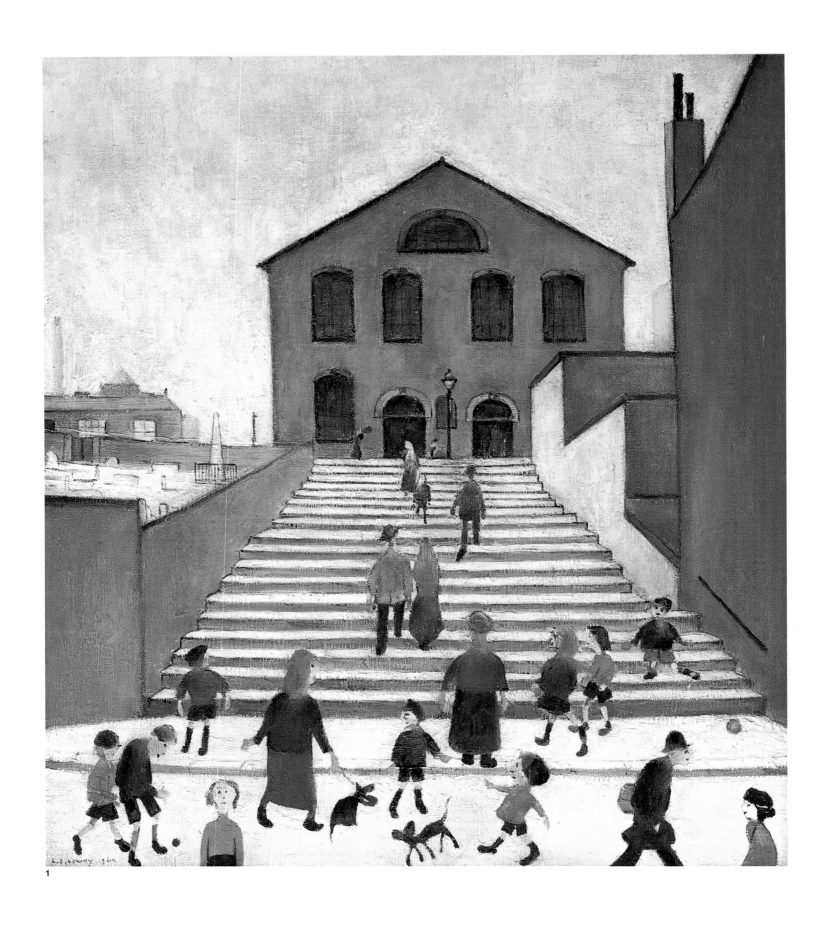

1

The Primitive Methodist Church in Morton Street, Middleton, and the 24 steps which lead up to it, were built at separate times. The steps were built in about 1851, when a highway was constructed from the Market Place through Boarshaw to Royton Summit; the church was built about 30 years later.

1 *Old Church and Steps* (1960), oil on canvas, 61.0 x 50.0 cm. How could Lowry resist this subject? United here are two of his favourite images, the church and the steps, which could be painted almost without alteration. As for the figures, they would have been taken from the numerous studies the artist made over his lifetime.
2 Photograph: church and steps, Middleton. The church and steps remain much as they were in 1960, although the church is now an industrial unit and the cemetery is no longer in use.
3 Photograph: Lowry on the steps leading to the Primitive Methodist Church, Middleton.
4 Article from the *Manchester Evening News* (c 1960), showing the original painting, *The Twenty-four Steps*, which Lowry made of this site.

3

Lowry was asked to paint a Middleton picture by the *Middleton Guardian* photographer, Robert Smithies. After they had wandered around the town looking at various scenes, with Lowry showing only a passing interest in most of them, the 24 steps were suggested. Upon seeing them, with the church at the top, Lowry immediately knew what subject he had to do. 'Now I really must paint that. What do you think? Isn't that the best we've seen so far? Look at the way that wall sweeps down to the right. And those old railings. I'm glad they pulled those houses down. That makes a lovely picture… You would think that chapel would dominate the steps; but it doesn't, you know. It's the other way round. Now do you like this? Good! Good!' And *The Twenty-four Steps* was completed.

Not satisfied with one painting of the subject, Lowry did another, entitled *Old Church and Steps*. This view had an unusual addition: a dog with five legs stands at the front of the painting. When this was pointed out to Lowry by a friend, he replied: 'Well I never! And to think I checked it most carefully before I let it go. All I can say is that it must have had five legs - I only paint what I see, you know.'

Mr Manchester's DIARY

If you happen to have £5,000 to spare...

THIS painting by L S Lowry is to be auctioned in Manchester on September 18, and is expected to fetch more than £5,000. It was painted in 1960, and belongs to a man who has been collecting paintings for many years.
'Old Church And Steps' shows a former Middleton church which is now used by a clothing manufacturer.
The Lowry — and paintings by other artists — will be sold at Manchester Auction Mart, Atkinson Street, Deansgate.

This Lowry could be yours at auction.

4

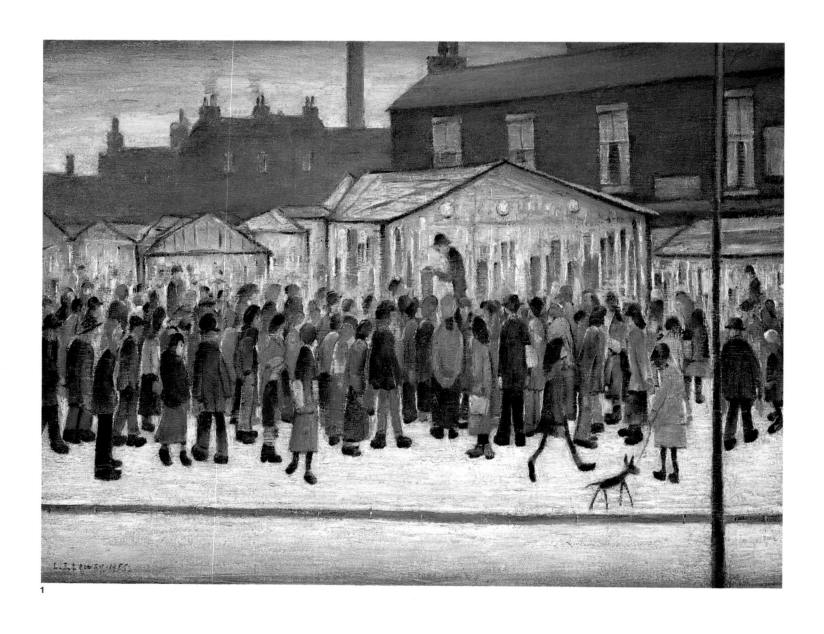

1

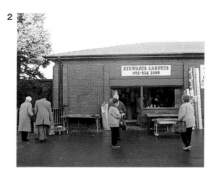

In 1833, market traders of Oldham started their own market in a large field called Curzon Ground, or, familiarly, Tommy field, named after Tommy Whittaker who had leased the land in the 1800s.

1 *The Lino Market, Oldham* (1955), oil on canvas, 46.0 x 61.0 cm. In this later view of Oldham Market, Lowry has given the foreground figures of the crowd a sense of movement, a characteristic of his later industrial works. It also contains one of Lowry's most endearing images - a dog.
2 Photograph: lino market, Oldham. The terraced buildings behind the market have been demolished but the market itself, now modernised, remains an important part of Oldham life. The carpet/lino stall run by the Stewarts is situated in a permanent building.
3 *Selling Oilcloth on the Oldham Road* (1914), oil on board, 29.2 x 39.2 cm. In this early version of the market, Lowry has not yet learned to imbue his tightly grouped figures with movement and life.
4 Photograph: Tommy Field Market, Oldham.
5 Photograph: Stewart's lino stall at Tommy Field Market, Oldham.

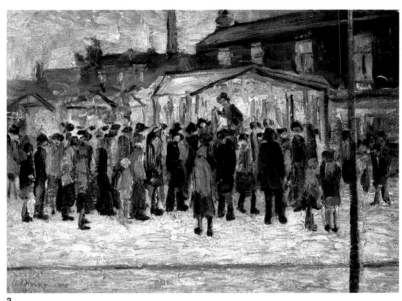

3

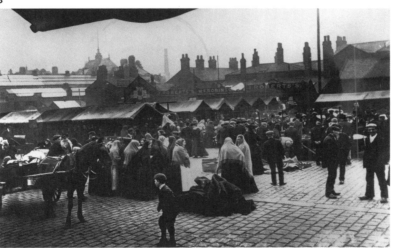

4

5

In 1896, one of the stalls in the Tommy Field market was taken by a Mr Stewart, who sold carpets, floor-coverings and hardware. Sometime before 1914, having spent the day collecting rents on the Oldham Road, Lowry went into Oldham. It was here that he saw the lino-seller, not a seller of oilcloth, and not on the Oldham Road as the title of the painting suggests (Lowry occasionally misnamed the location of his paintings, among them *Dwellings, Ordsall Lane* and *Irk Place*). In 1955, however, when he once again used the lino-market as a subject, he correctly placed it within the Lancashire town.

The composition and features of the two paintings are so similar that there can be no doubt that they both represent the same view. It is interesting to note that in both pictures, with over forty years dividing them, Lowry has used the same method to separate the viewer from the scene. The difference between the two works lies in their styles, the earlier one rendered in a more impressionist manner.

'It fascinates me, dominates my imagination. As you know, my pictures are often based on separate fragments of reality which I fit together to create townscapes. Not all my pictures, by any means, are topographically accurate, many are composite, and it is into these composite pieces that the Stockport Viaduct so often creeps, like some recurring subject in a dream.'

The Studio

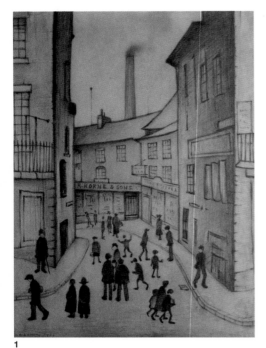

1

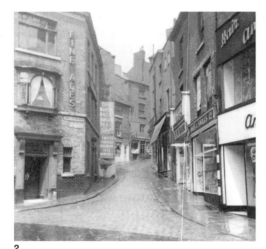

2

1 *Mealhouse Brow* (1929), pencil on paper, 25.4 x 35.5 cm
2 Photograph: Mealhouse Brow
3 Photograph: Lowry in Stockport, the viaduct in the background.

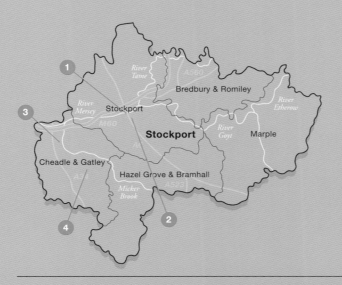

Stockport

To the south, on the outskirts of the industrial cities, Lowry also found images that he could add to his iconography. The great red brick viaduct, the isolated houses and the steep steps of a curving street were topo-

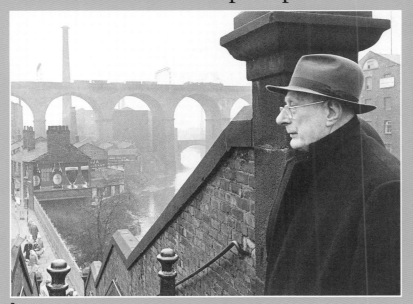

3

graphically illustrated, and then they were plucked from their settings and rearranged in numerous sites in his composite paintings.

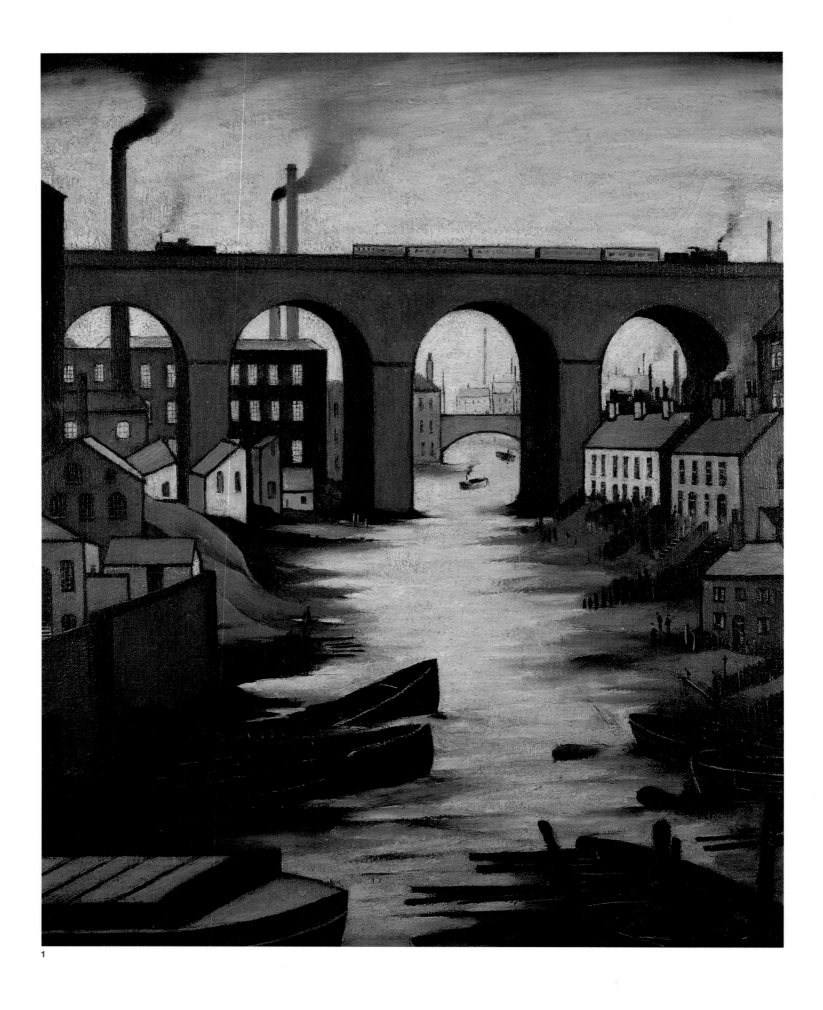

1

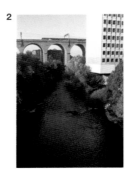

Stockport Viaduct over the River Mersey opened in 1839. It is about one-third of a mile in length, consists of 20 large semi-circular arches and two smaller ones at each end, reaches a height of over 110 feet from the river-bed and was constructed with over ten million bricks.

1 *Stockport Viaduct* (1944), oil (primary support unknown), 59.6 x 49.4 cm. Painted seven years after *The Lake* (see page 36), the River Mersey in Stockport is represented in much the same way as the Irwell in Salford. Both were shown surrounded by abandoned, derelict sites. The styles of the two paintings, however, are distinct. In this later work, Lowry painted the industrial structures which surround the river in bold, simple shapes, each independent of the other; in the earlier work, all facets of the whole were integrally linked.

2 Photograph: Stockport Viaduct. The viaduct still stands, as do the buildings on the left and the now-derelict sheds. A large tower block obscures the view of the viaduct; steam trains only run for excursions on an electrified line.

3 *Stockport Viaduct* (1943), pencil on paper, 35.5 x 25 4 cm. A view of Stockport Viaduct on which the painting was based.

4 Photograph: the River Mersey with Stockport Viaduct in the background.

5 *Stockport Viaduct* (1942), pencil on paper, 27.0 x 20.0 cm. An early sketch of the viaduct with five of its arches showing. Note the compositional differences to the painting: both structures and perspective have changed.

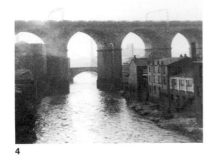

3

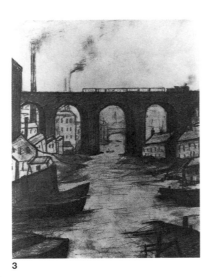

4

Lowry found the imagery of the massive bridge over the river, itself flanked by industrial buildings and decaying boats, an irresistible one. From what had started as a drawing which accurately represented the scene, *Stockport Viaduct* evolved into a painting of desolation. The buildings with their empty dark windows show their faces to the viewer; the half-drowned boats and jetty with its skeletal ribs seem to form a triangle of débris almost blocking the waterway.

The emotional impact of the work, painted five years after the death of his mother, shows that Lowry was still in mourning, his loneliness strong and needing expression.

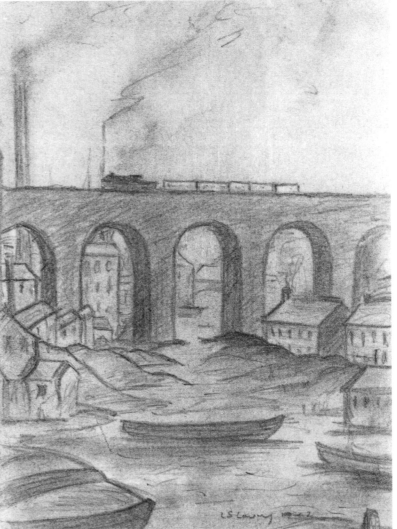

5

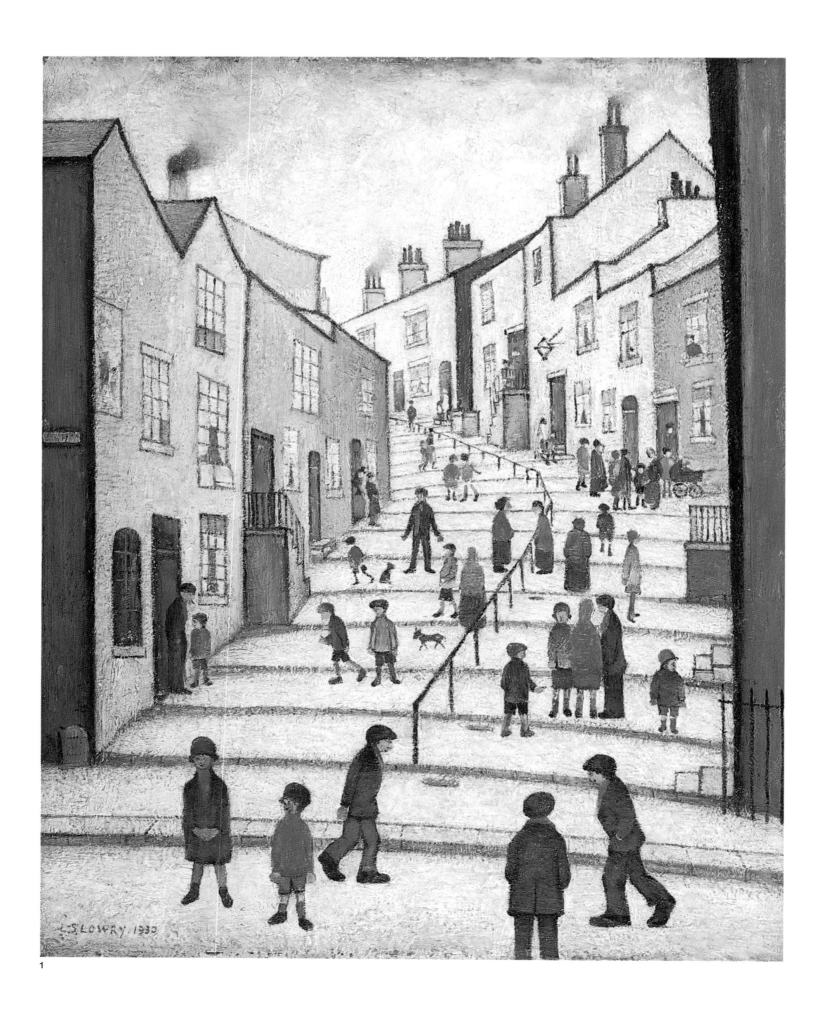

1

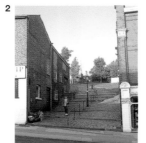

2

In the heart of what had been a central and busy part of Stockport, Lowry discovered Crowther Street. Steep and curved and flanked by rows of terraced houses, the deep steps climb from Lower Hillgate to Lawton Street.

1 *A Street in Stockport: Crowther Street* (1930), oil on board, 51.5 x 41.3 cm. On this busy street appear many of the figures which Lowry had gathered over the years, including the man who stands at the edge of the painting, watching.

2 Photograph: Crowther Street. The steps now lead to a car park and have small shops on their right, in what had been the terraced houses, and on their left the row has been demolished.

3 *Sketch for A Street in Stockport: Crowther Street* (undated), pencil on paper, c 14.0 x 10.5 cm. An early sketch of the scene with only the basic outlines marked in.

4 *Crowther Street, Stockport* (1934), pencil on paper. This later version of the scene is different in detail from both the painting and an earlier drawing: windows have been moved, fences and doorways have been changed or added and the figures are distinct in both the style and cast of characters.

5 *The Stepped Street* (1929), pencil on paper, 37.x x 27.5 cm. This shows the same view as the painting, but with slight changes in the composition – such as the fence in the lower right of the painting. The drawing, however, and the characters are very similar.

6 Photograph: Crowther Street, Stockport.

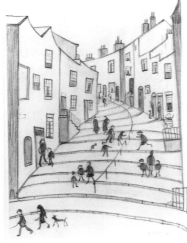

3

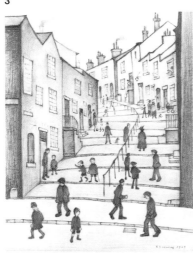

4

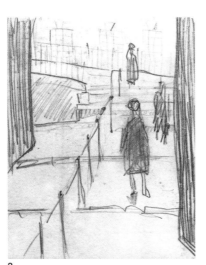

5

6

Steps, like gateways, are an important part of Lowry's imagery. The houses themselves, as the road climbs, have steep steps leading to their front doors. This type of step, parallel to the street, is an image often found in other works by the artist.

Lowry painted the houses white and shades of pink. His explanation for this unusual colour scheme was as follows: some of the houses on the right had recently been pointed and the façades freshened up by the application of a rubbing brick. The picture was painted in bright light and, apparently, the pink effect came from the sun shining on the refurbished brickwork.

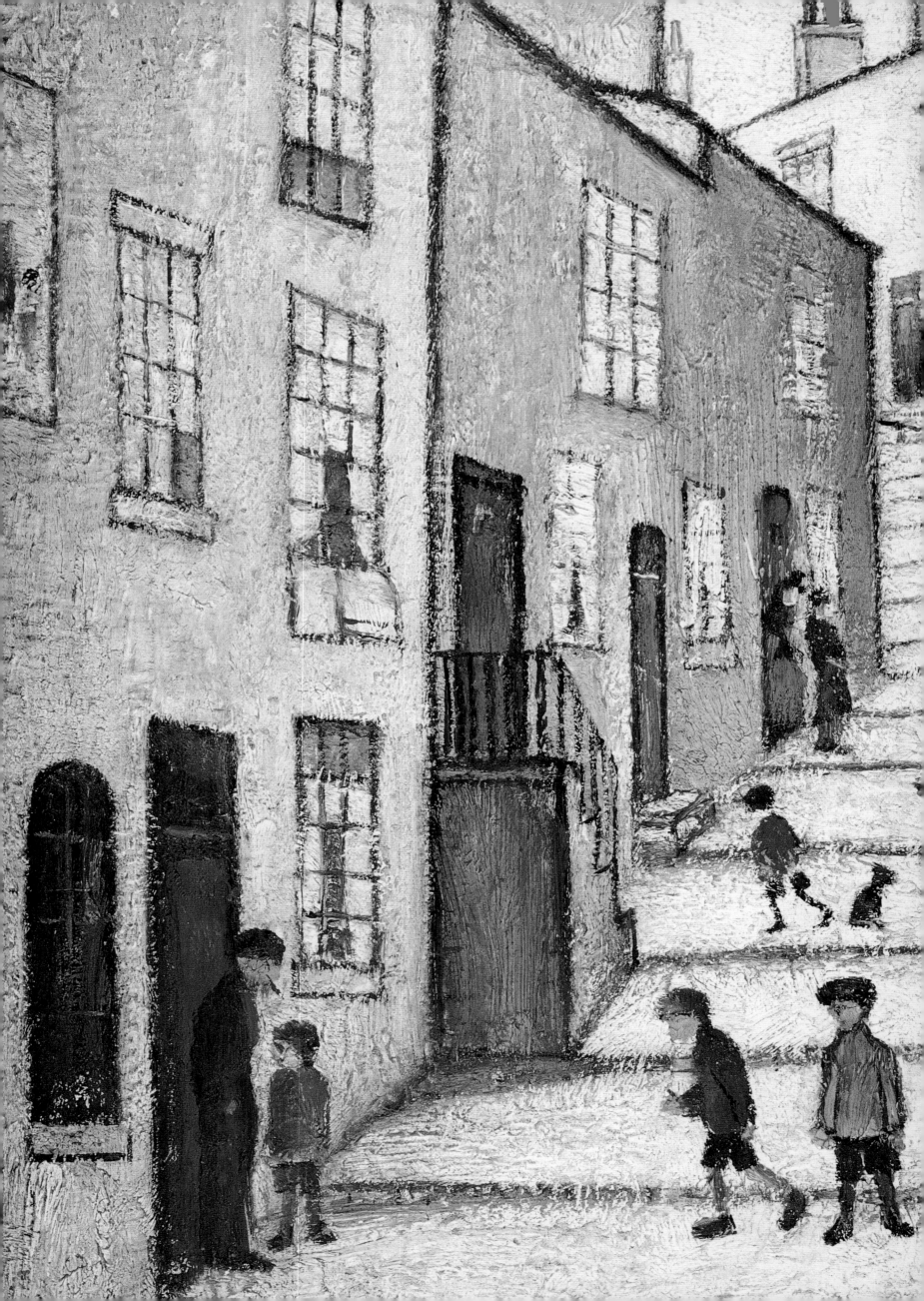

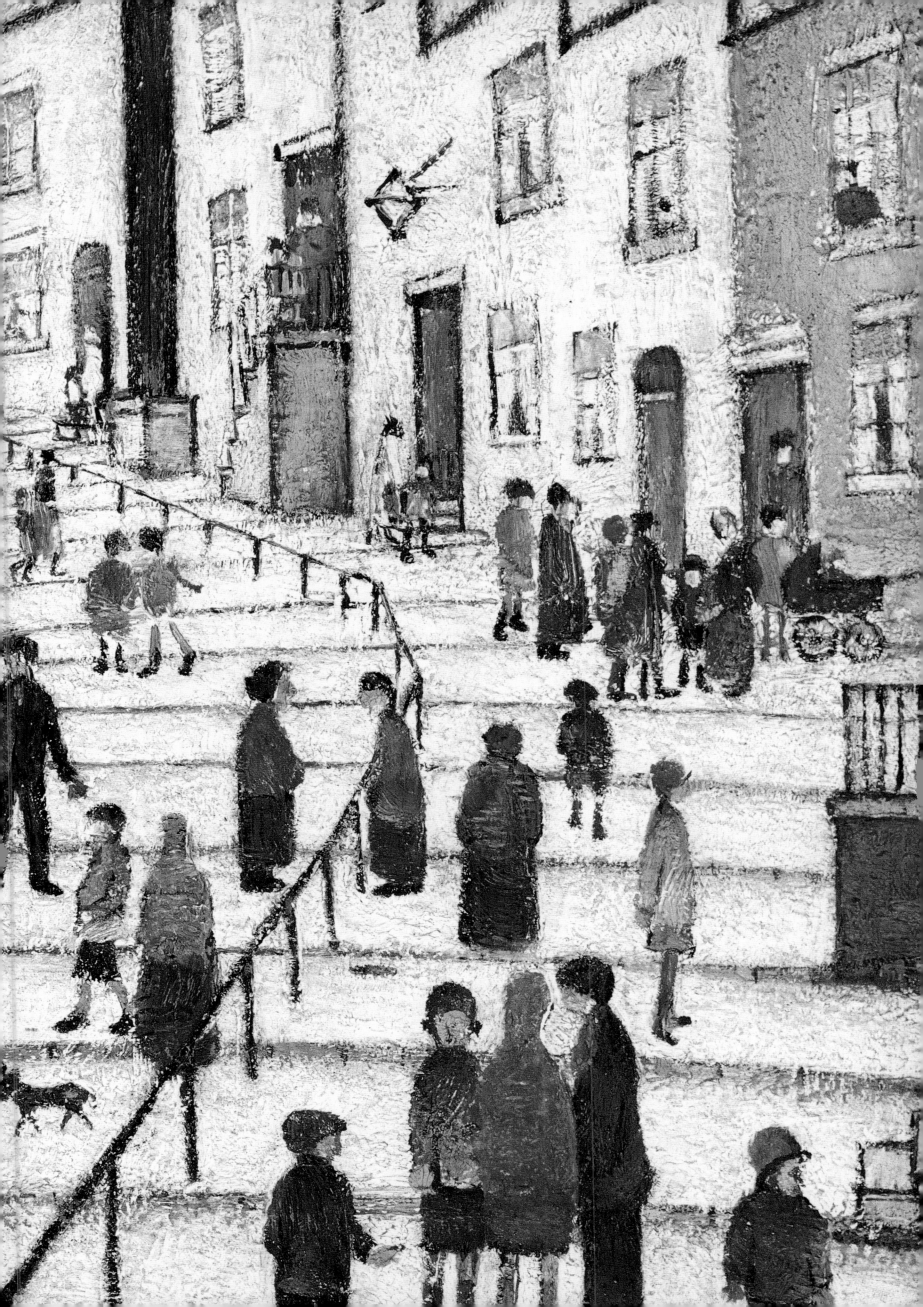

1

2

In the village of Gatley, in Cheshire, Lowry found High Grove House. This mansion was built in the mid-18th century in the High Grove Estate for the Bowers family, who were hatters from Yorkshire and Manchester. It was demolished in the early 1960s.

1 *The Empty House* (1934), oil on plywood, 43.2 x 51.3 cm. Standing abandoned and alone, this house represented Lowry's emotional state.
2 Photograph: site of High Grove House. The house, which stood on a bank about 45 ft high, has been demolished. Only a few stones remain, marking the edge of the garden. The remainder of the site is woodland.
3 *Old House* (1936), pencil on paper, 24.7 x 34.9 cm. An accurate rendition of the house and its surroundings, this drawing includes the two short flights of steps leading up the hill which also appear in the painting.
4 Photograph: High Grove House, Gatley.
5 *Old House, Gatley* (1937), pencil on paper, 27.5 x 39.5 cm. In this drawing, Lowry has incorporated changes not only to the house itself, but also to its environment. The trees have blacked out the sky and seem to enshroud the building.

3

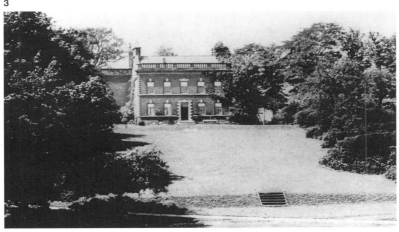

4

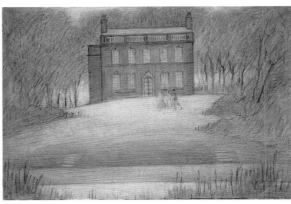

5

Lowry made at least two drawings of this building. The view which he chose in both cases was from directly in front so that he was, in fact, creating a portrait. However, by the time Lowry had produced his second drawing, he had instituted changes to the façade of the building. No longer are the door supports blocks of stone of alternating width; instead they are straight posts and support a pediment in place of a lintel. It is this version of the house that Lowry adopted for the painting *Empty House*. (The dates of the drawings and painting are suspect; Lowry is known to have occasionally misdated his works.)

High Grove House, with its sweeping lawns, has been turned into a scene of dereliction. The neat area of grass flanked by leafy trees has changed. In the painting the lawns become overgrown, and the soothing pond has filled with brackish water, weeds and broken posts. The trees, lush and shady in reality, have become leafless tortured shapes. Lowry painted this scene during the long illness of his mother, a time when lonely empty houses featured in many of his works.

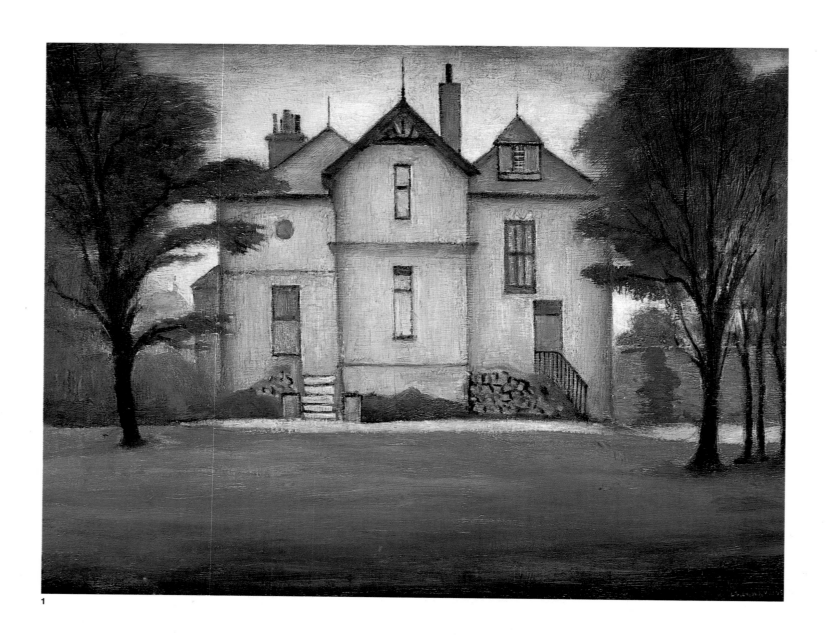

1

'Oaklands' was the house of Dr Hugh Maitland, Professor of Bacteriology at the University of Manchester and a friend of Lowry from the 1940s. It was situated in Cheadle Hulme, near Stockport, Cheshire, about six miles from Manchester.

1 *Portrait of a House* (1954), oil on canvas, 43.5 x 60.0 cm. The richness of colour apparent in this painting is due to Lowry's ability to create a full palette using only the three primary colours and black and white.
2 Photograph: site of 'Oaklands', Cheadle Hulme. A new housing development stands on the site of the large house, formerly set in its own grounds.
3 *Portrait of a House* (c 1947), pencil on paper, c 17.5 x 21.0 cm. The cursory suggestion of the trees and ground around 'Oaklands' is different to the rendition of the house itself; Lowry has not only drawn the basic outline of the building, he has shaded the façade to give it a sense of depth.
4 Photograph: 'Oaklands' in Cheadle Hulme, Cheshire.
5 *The Drive, 'Oaklands'* (1947), pencil on paper, 32.5 x 36.0 cm. The sketchy quality of this landscape was an unusual departure for Lowry at a time when his landscapes were made up of bold shapes and simple lines.

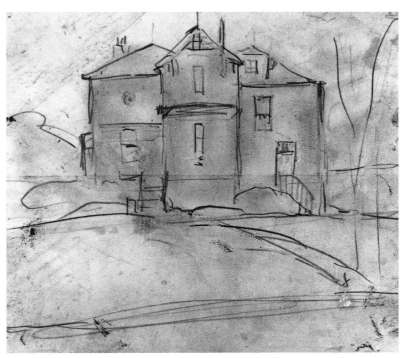

3

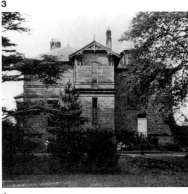

4

5

Here Lowry visited, often staying overnight. He spent time in the neighbouring countryside sketching, characteristically absorbed by the buildings and their surroundings. *Portrait of a House* (1954) is exactly that: a portrait of 'Oaklands'. We look at this painting as we would a portrait of a person painted by Lowry. The house sits centrally, flanked by trees pointing at the façade. The foreground, devoid of anything of interest, forces the viewer to see the empty windows and the blank surface. It appears as a staring face looking out. Yet, if we look at the sketch Lowry did of the house, and its photograph, we can see that, with the exception of small details, Lowry accurately depicted not only the physicality of the house, but also its sense of being.

The Drive, Oaklands, drawn in 1947 when the Maitland family moved into the house, is also an interesting work. It has the same sketchy quality that Lowry used in his early drawings, with an impressionistic rendition of the bare-branched winter shrubs.

Select Bibliography

Barber, Noel, 'L S Lowry', *Conversations with Painters*, Collins, London (1964).

Collis, Maurice, *The Discovery of L S Lowry*, Alex Reid & Lefevre, London (1951).

Horsely, Juliet, ed, *Lowry in the North-East*, Tyne and Wear Museum Service, Sunderland (1989).

Howard, Michael, *Lowry: A Visionary Artist*, Lowry Press, Salford (2000).

Leber, Michael, 'The Remarkable Legacy of L S Lowry', *Manchester Region History Review*, Vol I, No 2, Autumn/Winter 1987.

Leber, Michael and Sandling, Judith, eds, *L S Lowry*, Phaidon Press, Oxford (1987).

Levy, Mervyn, *Drawings of L S Lowry: Public and Private*, Jupiter Books, London (1976).

Levy, Mervyn, *The Paintings of L S Lowry*, Jupiter Books, London (1975).

Rohde, Shelley, *L S Lowry, A Biography*, Lowry Press, Salford, 2000 (first published 1979 as *A Private View of L S Lowry*).

Sandling, Judith and Leber, Michael, *L S Lowry, the Man and his Art*, City of Salford Art Gallery and Museums, Salford (1992).

Spalding, Julian, *Lowry*, Herbert Press in association with the South Bank Board, London (1987).

Authors' Acknowledgments

The authors wish to acknowledge the assistance and encouragement of the following:

Tim Ashworth at Salford Local History Library without whose knowledge and help this book would not have been possible; Sandra Hayton and Patricia Nuttall at Salford Local History Library; Staff at Tameside Local Studies Library, Stalybridge; Staff at Stockport Central Local Heritage Library; Staff at Middleton Local Studies Library; Staff at Manchester Local Studies Unit, Central Reference Library; Staff at Oldham Local Studies Library; Staff at Wigan Heritage Service.

Bill Aldridge, Wigan Archaeological Society; David Pratt; Margaret Buxton for allowing us to choose from the many examples of her late father's photographs; Pat Seddon for finding a difficult site; Derek Seddon for being available at all times for emergency and non-emergency photography; Bob Sandling for the enormous help he has given in what has been a long and arduous search; Ted Sandling for his proofreading and comments on the text, which were acted upon and for preparing the Lowry index and computer database; Shelley Rohde, for reading the manuscript with care and providing insight into various aspects of Lowry's life, and allowing us to quote from her biography of L S Lowry; Carol Lowry for reading the manuscript, giving permission to reproduce many of the images included in this book, and, most important, being a consistent supporter of our work; Margery Clarke, who has given us support for so many years; all the authors whose published work has been so useful to the research for this book and who have been quoted in the text.

Crane Kalman Gallery; Victoria Law and staff at the Richard Green Gallery for keeping us informed about their Lowrys and giving their support to this project; Susan Kent of Sothebys for providing transparencies and photographs at a moment's notice; Messrs Christies, Phillips and Bonhams for providing transparencies and photographs.

The many private collectors whose work we have reproduced; Tom Cross, for the sketch of *Going to Work*; Dr John Maitland for being generous with his time and providing photographs of 'Oaklands'; Michael Leitch, our editor, who has provided much encouragement; Martin Tilley for the book design; Eric Sutcliffe, Weir Pumps Ltd, for giving his time to find the Mather and Platt magazines; John Finnan, who has researched Lowry's places over the whole of the British Isles and shared his information; Geoffrey Shryhane; Graham Hesketh; Mr McEwan; Selwyn Demmy for being so generous with his collection.

All those who answered our call for help in identifying *Industrial Landscape* (1925) as the Wigan Coal and Iron Works; All those who answered the newspaper article about Irk Place, Angel Meadow; Chris Makepeace for the photographs of St Michael and All Angels Church, Angel Meadow and Exchange Station.

Len Grant, not only for the photographs which he took of the sites Lowry depicted, and the time he spent in providing the information relating to them, but for his enthusiasm and excitement.

All the Staff at the City of Salford Art Gallery and Museum; the Lowry Trust; the Staff at The Lowry; Roger Sears for producing this book; The City of Salford, which for over 60 years has encouraged the collection of paintings and drawings by L S Lowry and supported the study of the artist and his work.

Gallery Acknowledgments

Ulster Museum, Belfast: *Street Scene* (1947), p 64 (1).

City Museum and Art Gallery, Birmingham: *An Industrial Town* (1944), title page.

Bradford Art Galleries and Museums, Cartwright Hall: *Industrial Landscape Ashton-under-Lyne* (1952), p 84 (1).

Bury Art Gallery: *A River Bank* (1947), p 39 (4).

Glasgow Art Gallery: River Scene (1942), p 37 (4).

Usher Gallery, Lincoln: *View of a Town* (1936), p 63 (3); *Britain at Play* (1943), p 63 (4).

Arts Council of Great Britain, London: *The Park* (1946), p 49 (3).

© Crown copyright: UK Government Art Collection, London: *Lancashire Fair, Good Friday, Daisy Nook* (1946), p 89 (4).

Imperial War Museum, London: *Going to Work* (1943), p 76 (1).

Royal Academy of Arts, London: *Station Approach* (1962), p 75 (4).

The Tate Gallery, London: *Dwellings, Ordsall Lane, Salford* (1927), p 54 (1); *Study for Dwellings, Ordsall Lane, Salford* (1927), p 55 (4); *Industrial Landscape* (1955), p 77 (3).

City Art Gallery, Manchester: *The Viaduct, Store Street, Manchester* (1929), p 60 (2); *St Augustine's Church, Manchester* (1945), p 68 (1); *Piccadilly Gardens (Manchester)* (1954), p 66 (1); *St John's Church, Manchester* (1938), p 70 (1).

Whitworth Art Gallery, University of Manchester: *View in Pendlebury* (1936), p 19 (4); *Ancoats Hospital Outpatients' Hall* (1952), p 72 (1).

Laing Art Gallery, Newcastle-upon-Tyne: *River Scene* or *Industrial Landscape* (1935), p 37 (3).

Museum and Art Gallery, Newport, Gwent: *Francis Street, Salford* (1957), p 42 (1).

Castle Museum, Nottingham: *The Arrest* (1927), p 87 (5).

City of Salford (on loan to The Lowry): pp 8, 9, 10, 14 (all); *Pendlebury Scene* (1931), p 17 (3); *St Augustine's Church, Pendlebury* (1930), p 23 (5); *St Mary's Church, Swinton* (1960), p 25 (3); *St Mary's Church, Swinton* (1913), p 25 (5); *The Lake* (1936), p 36 (1); *River Irwell at the Adelphi* (1924), p 37 (5); p 43 (3); *Francis Terrace* (1956) p 43 (3); *A Street Scene - St Simon's Church* (1928), p 50 (1); *St Simon's Church (A Street Scene - St Simon's Church)* (1927), p 51 (3); *St Simon's Church* (c1927) p 51 (4); *By St Philip's Church* (1926), p 53 (3); *Oldfield Road Dwellings* (1929), p 55 (3); *Playground* (c 1927), p 63 (5); *Manchester Blitz (St Augustine's Church), Hulme* (1943), p 69 (4); *St John's Church, Deansgate* (1920), p 71 (4); *Sketch of St John's, Manchester* (c 1920), p 71 (6); *Portrait of a House* (1954), p 106 (1).

City of Salford Art Gallery: pp. 11, 12 (all), *The Terrace, Peel Park* (1927), p 45 (3); *Peel Park Sketch* (c 1927), p 45 (4); *The Steps, Peel Park, Salford* (1930), p 45 (5); *Peel Park, Salford* (1927), p 46 (1); *Peel Park Sketches*, p 47 (3,4,5); *Bandstand, Peel Park, Salford* (1925), p 49 (4); *Bandstand, Peel Park* (1928), p 49 (5).

Atkinson Art Gallery, Southport: *Street Scene* (1935), p 16 (1).

Memorial Art Gallery, Stockport: *A Street in Stockport: Crowther Street* (1930), p 100 (1); *The Stepped Street* (1929), p 101 (5).

City Museum and Art Gallery, Stoke-on-Trent: *The Empty House* (1934), p 104 (1).

Borough of Thamesdown Museum and Art Gallery: *Winter in Pendlebury* (1943), p 24 (1).

City of York Art Gallery, York: *The Bandstand, Peel Park, Salford* (1931), p 48 (1).

Photographic Acknowledgments

All modern location photographs are © Len Grant, with the exception of those by Derek Seddon listed below. Other photographs were kindly supplied by:

Bolton Evening Record: p 31.

Bridgeman Art Library: 18, 20-1, 39 (4), 48, 63 (3, 4), 104.

Margaret Buxton (photographer Harry Buxton): p 91 (3).

Margery Clarke (photographer Crispin Eurich): p 97.

Carol Lowry: p 73.

John Maitland: p 107.

Chris Makepeace: pp 65, 75 (5).

Manchester Evening News: (article), p 93.

Manchester Local Studies Unit, Central Reference Library: pp 60, 67 (5), 69, 71 (3).

Oldham Local Studies Library: p 95.

David Owens, *Canals to Manchester:* p 83.

Popper photo: pp 33, 35, 55 (6).

Private Collection: p 93.

Harold Riley: pp 15, 81.

HSBC: 17 (5).

Salford Local History Library: pp 14, 17, 19 (5), 23, 25, 27, 39, 41, 43, 45, 47, 49, 51 (5), 53, 55 (5), 57, 59.

Salford City Archives (photographer Samuel Colthurst): p 75 (3).

City of Salford Art Gallery: pp 19 (6), 37, 71 (7) - photographer Reverend Geoffrey Bennett

Derek Seddon, modern photographs: pp 91, 105.

Derek and Pat Seddon: p 105.

Stockport Central Local Heritage Library: pp 96, 99, 101.

Tameside Local Studies Library, Stalybridge: pp 85, 87 (3), courtesy Garry Jones (5), 91 (4, 5).

Dennis Thorpe *(The Guardian)*, p 80.

Unknown: p 61.

Weir Pumps (formerly Mather and Platt Park Works): p 77.

Wigan Heritage Service: p 29.